Fantastic Forgeries

Paint Like

Van Gogh

A Step-by-Step Course to Painting
Van Gogh's Classic Artworks

Susan Lea and Joanne Shurvell

Race Point
PUBLISHING

Quarto is the authority on a wide range of topics.

Quarto educates, entertains and enriches the lives of our readers—enthusiasts and lovers of hands-on living.

www.quartoknows.com

First published in the United States of America in 2017 by
Race Point Publishing, a member of
Quarto Publishing Group USA Inc.
142 West 36th Street, 4th Floor
New York, New York 10018
quartoknows.com

10 9 8 7 6 5 4 3 2 1

ISBN 978-1-63106-146-2

Library of Congress Cataloging-In-Publication Data

Names: Shurvell, Joanne, author. | Lea, Susan, 1983- illustrator.
Title: Fantastic forgeries : paint like Van Gogh : a step-by-step course to
 painting Van Gogh's classic artworks / Joanne Shurvell, Susan
 Lea, Van Gogh Museum, Amsterdam
Description: New York : Race Point Publishing, 2016. | Series: Fantastic
 forgeries
Identifiers: LCCN 2016027391 | ISBN 9781631061462 (paperback)
Subjects: LCSH: Painting--Technique. | Drawing--Technique. | Gogh, Vincent
 van, 1853-1890--Miscellanea. | BISAC: ART / Individual Artists / General.
 | ART / Techniques / Drawing. | ART / Techniques / Painting.
Classification: LCC ND1473 .S52 2016 | DDC 750.28--dc23
LC record available at https://lccn.loc.gov/2016027391

Editorial Director: Jeannine Dillon
Managing Editor: Erin Canning
Project Editor: Jason Chappell
Creative Director: Merideth Harte
Interior Design: Jon Chaiet
Cover Design: Phil Buchanan
Artist photo: Tawni Bannister
Author photo: Christine de León

Printed in China

Contents

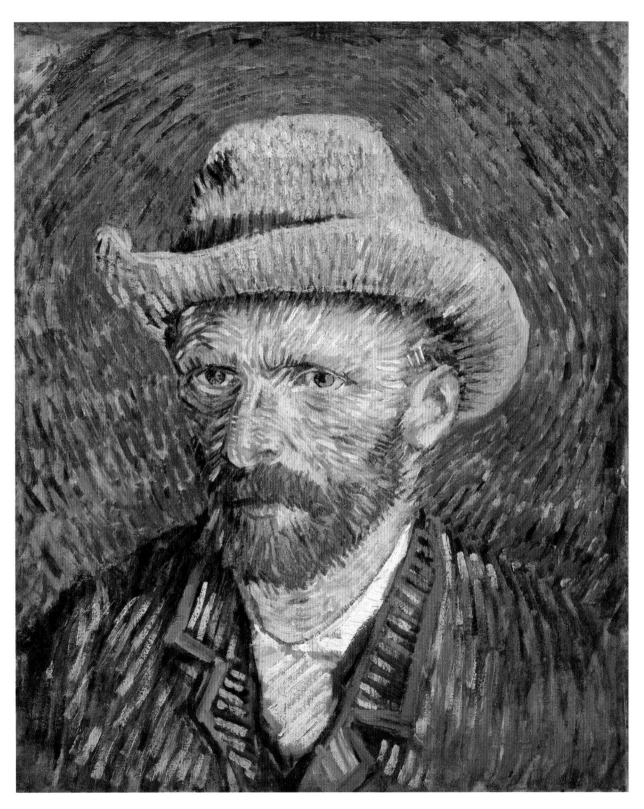

Self-Portrait with Grey Felt Hat, 1887, Van Gogh Museum, Amsterdam (Vincent Van Gogh Foundation).

Materials

Oils

This book recommends a specific brand of oil paint: Holbein Duo Aqua oils. These paints have rich color and texture that other brands lack. They blend together well, creating vibrant new colors, rather than making ugly colors that set your paintings up for disaster. At the beginning of every painting, the list of materials indicates the Holbein Duo Aqua oil colors that you will need and has a small color swatch for easy reference. Professional artists find that Holbein is the best quality oil paint on the market and say that it is well worth the money.

If you decide to use a different brand of oil paints, simply try your best to match the color swatch next to each Holbein Duo Aqua color at the beginning of each painting. Keep in mind that other brands will not be as bright or as vibrant as Holbein. Also remember that if you have matched the color swatches with other brands, the resulting colors may vary and you could end up with dramatically different results than when Holbein paints are mixed. This may make it difficult to accurately match the forgery instructions.

Finally, a secret benefit to Holbein paints—if you only use Holbein paints—is that they are easy to clean up with water. Other brands of paint require solvents to clean off of surfaces and may permanently stain clothing. Holbein wipes off surfaces with just soap and water and most colors of the paint wash out of clothing.

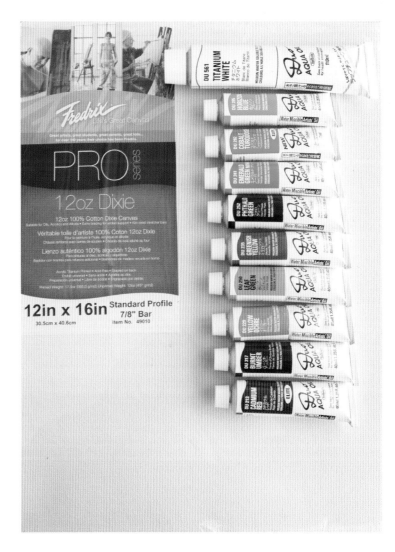

12 × 16-inch (30 × 40 cm) Canvas

Van Gogh painted his masterpieces on burlap that he stretched onto canvas. All of his canvases have odd dimensions, probably because he just stretched the burlap over whatever wood was easily available. To make it relatively simple to successfully forge your own Van Gogh, these painting have been slightly modified to fit on a standard 12 × 16-inch (30 × 40 cm) canvas. The recommended canvas is Fredericks Pro Series 12 oz Cotton Dixie. You will find all of the templates for these images beginning on page 162. You will need to increase them by 180 percent in order to trace them, or you can copy directly.

Easel

While you do not need an easel, it will make painting a much more enjoyable experience. Using an easel allows you to stand up straight. With an easel you can also step away from the canvas and look at it from different perspectives.

Brushes

Each project will require some or all of these brushes:

Round brush nos. 1 and 2: Round brushes are useful for washes, filling space with color, and creating lines. Round brush no. 1 is smaller than round brush no. 2 and so can be used in smaller spaces.

Detail round brush no. 1: Detail round brushes are useful for the tight spaces that require fine lines and detail work. This is the smallest brush required for these forgeries.

Flat brush nos. 1, 2, and 4: Flat brushes allow you to quickly fill space with color and can be used for bold, sweeping strokes. These brushes leave a distinct texture. You can use the edge of the bristles to create fine lines. Round brush no. 1 is the smallest, followed by 2, with no. 4 being the thickest. Flat brush no. 4 is best for the backgrounds and large areas because it covers a large space in fewer strokes.

Palette

The palette is useful because it gives you a place to keep your paints nice and organized. It also provides a clean space to mix colors. You can buy a fancy palette from an art supply store or use something more basic, like a paper plate. The mixing of colors is important in creating an accurate forgery, so don't try to go without a palette!

Preparing Your Canvas

Before you begin painting your fantastic forgery, there are a few introductory steps to make the process smoother. First, you need to prime the canvas so that a burlap color, similar to the burlap Van Gogh painted on, shows through any unpainted spots. Then, you need to draw a grid so that it is easier to accurately match Van Gogh's proportions. Finally, you need to draw a sketch of the painting over the grid so that you know where to paint certain components. This helps make painting your masterpiece much easier.

Priming Your Canvas

Van Gogh painted on stretched burlap, so in order for your forgery to achieve the same look, you have to prime the white canvas. Use Raw Sienna acrylic paint (we suggest using Holbein Heavy Body Artist Acrylic) for this because it dries faster, allowing you to start painting sooner. Use a palette knife to quickly spread the paint around the canvas, and then go over the paint with a damp sponge or paper towel to further

spread the paint. This ensures a thin, even layer of paint across the entire canvas. Don't forget to cover the sides of the canvas; there's nothing like finishing your masterpiece and realizing that the sides reveal that it's a forgery because they are blindingly white.

Gridding Out Your Canvas

Gridding out your canvas helps you keep the proportions of Van Gogh's paintings in your forgeries. Use a pencil and a T-square or a ruler when gridding out the canvas. A T-square is preferable because when you line up the plastic "T" with the side of the canvas, it ensures that you will get a perfectly straight line at the correct angle.

Start by going across the canvas horizontally, making a mark every 2 inches (5 cm). Flip your T-square or ruler so that it is vertical and repeat the process of making a mark every 2 inches (5 cm). If you are using a T-square, simply draw straight across the canvas to create a straight line. If you are using

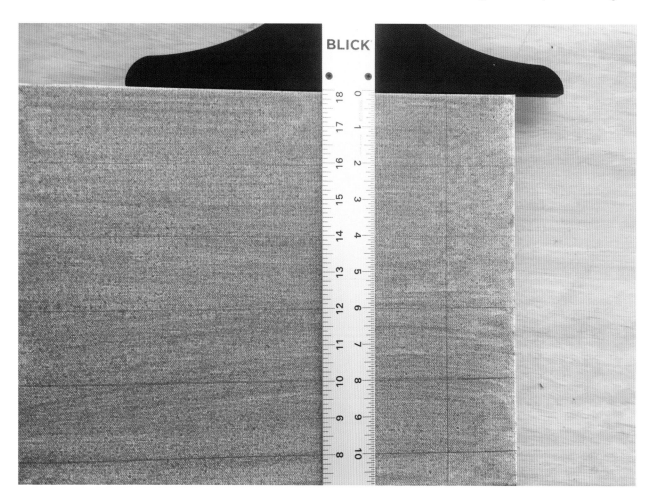

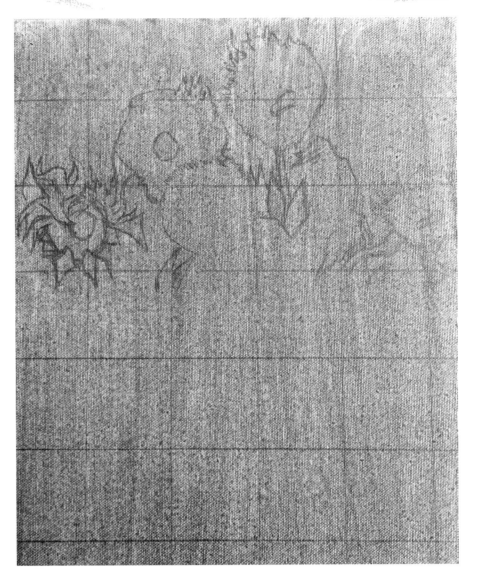

Drawing on Your Canvas

It is very important that the drawing be accurate because it is the guide to the entire painting. Without this guide, you may end up painting something very different from Van Gogh's masterpieces. Drawing the image also helps you save time later because it means that all of your guides are already established before you paint.

Templates for each image are supplied at the back of the book, starting on page 162. They are not to size, because this book isn't large enough to print them at the size of your canvas—you will have to increase each template by 170 percent in order to sketch it accurately. You can either free-form sketch the template onto your canvas or trace the template. If you want to trace the template, use a copy machine to increase the size of the template by 180 percent.

To make the drawing process easier, consider each square of the grid separately so that you don't get overwhelmed. Take the process slowly, drawing one

a ruler, draw guide dots at the edges of the canvas where you will need to draw the lines, and then use a ruler to connect them. You will end up with a grid of 48 squares that are 2 × 2 inches (5 × 5 cm) each.

Until this point, you can still be deciding which painting you will complete because the grid is identical for both portrait and landscape paintings. Simply turn the canvas to whatever orientation is needed for your masterpiece.

square at a time. Break the square into lines and shapes with your eyes; try not to see what Van Gogh painted as a whole, but the lines and negative space instead. Feel free to take breaks and come back to the drawing later if you become overwhelmed, and simply pick up where you left off.

Once you have finished the drawing, go over it with a light pink Prismacolor marker. Make sure not to go over the grid lines, because you will erase those before you start painting.

Now that the image is outlined in the light pink marker, use an eraser (we suggest a Pink Pearl Eraser) to erase the grid lines and any stray pencil marks. Skipping this step will allow the graphite from your pencil to blend with the paint and discolor it, especially lighter colors such as yellow. You will have no problems with the marker blending with the paint. Using the marker has the added benefit of making sure that you apply paint as thickly as Van Gogh did, because you will need to hide the marker lines.

The Painting Process

The paintings are organized in the order of easiest to hardest—with *Almond Blossom* being the easiest and *Fishing Boats on the Beach at Les Saintes-Maries-de-la-Mer* being the hardest. It is recommended that you read through the entire instructions for a painting at least once before you begin. For each painting, keep the completed forgery (pictured at the end of the chapter) and the Van Gogh original (pictured at the start of the chapter) in mind as you paint, and refer back to them as much as necessary. These oil paints take a long time to dry, so if you begin to feel overwhelmed, feel free to take a short break and return to the painting once you are recharged.

Paint Amounts

Throughout the book, you will notice that paintings call for different amounts of paint, typically dots, peas, and quarters. This is what is meant by these measurements:

Quarter Pea Dot

Keep all of your paint mixtures on your palette, even once the instructions move on to another color. You will eventually, toward the end of the painting, use the rest of your paint to add details and Van Gogh's signature texture. By Van Gogh's signature texture, we mean thick layers of paint.

Whenever the instructions refer to a color without an amount, that means that you should use leftover paint that is already on your palette.

Cleaning Your Brushes

Avoid contaminating your brushes, unless contamination is desirable, in which case the instructions will say as such. To clean your brushes, wipe them with a paper towel or rinse them in water between color changes. If you choose to rinse them, always remember to wipe them dry before loading the brush with paint.

Painting the Canvas Sides

Painting the sides of the canvas is an easy step and gives your painting a finished, polished look. However, it is an optional step. Simply take whatever color is at the edge of the canvas and wrap it around the side, continuing the general shapes and lines.

Drying Time

All of these paintings will take approximately three days to fully dry. Lay a completed painting with the painted side up on a flat surface until it is completely dry.

Storing

While the painting is drying, and even after if you need to store it longer, set the painting on a piece of newspaper. Newspaper will protect whatever furniture the painting is sitting on from getting paint all over it.

Almond Blossom

SAINT-RÉMY-DE-PROVENCE, FRANCE, FEBRUARY 1890

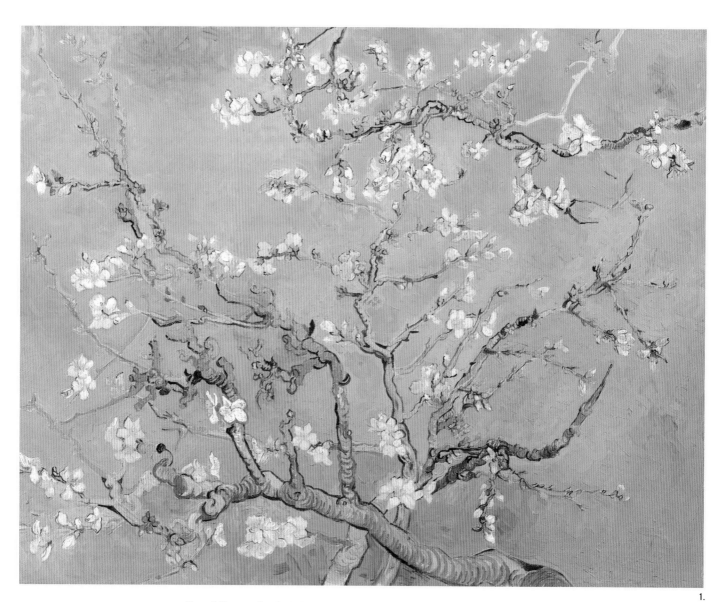

Almond Blossom, Van Gogh Museum, Amsterdam (Vincent van Gogh Foundation).

> "Work was going well, the last canvas of the branches in blossom, you'll see that it was perhaps the most patiently worked, best thing I had done, painted with calm and a greater sureness of touch."

—Vincent van Gogh in a letter to his brother Theo van Gogh, March 1890

A group of paintings of blossoming almond trees made by Vincent van Gogh between 1888 and 1890 shows the influence of the Impressionists, who were in turn influenced by Japanese art that had recently come into vogue. The Japanese Pavilion at the 1867 World Expo in Paris exposed the West to the Japanese aesthetic for the first time. Furniture, ceramics, silks, and prints from Japan became popular, and Van Gogh had a large collection of Japanese woodcut prints.

Van Gogh's admiration for the Japanese prints' flatness of surface and boldness of design can be seen in this still life of delicate almond blossoms against a blue sky. The flowers, the bold outlines, and the positioning of the tree in the painting are borrowed from Japanese printmaking. The white blossoms were originally pinker but have faded over time with exposure to light, losing some of their intensity.

In a letter to his brother Theo, Van Gogh said that he envied "the Japanese artists for the incredible neat clarity which all their works have" and the ease with which they appeared to produce their work. He described this "as simple as breathing; they draw a figure with a couple of strokes with such unfailing easiness as if it were as easy as buttoning one's waistcoat."

Van Gogh made this painting for his newborn nephew, Vincent Willem. His brother Theo wrote, "As we told you, we'll name him after you, and I'm making the wish that he may be as determined and as courageous as you."

Although *Almond Blossom* was intended to be placed over Theo and his wife Jo's bed, the couple displayed it over the piano in their living room. Unsurprisingly, it was the work that remained closest to the hearts of the Van Gogh family. Van Gogh's namesake Vincent Willem helped found the Van Gogh Museum in Amsterdam.

Almond Blossom

MATERIALS

- 16 × 12-inch (40 × 30 cm) canvas (you can work on a flat surface or an easel)
- Holbein Heavy Body Artist Acrylic in Raw Sienna
- Palette knife
- Sponge or paper towel
- Ruler or T-square
- No. 2 graphite pencil
- Prismacolor marker in Light Pink
- Pink Pearl Eraser
- Palette or plastic plate
- Round brush (no. 1)
- Detail round brush (no. 1)
- Flat brushes (nos. 1, 4)

OIL COLORS

- Titanium White
- Burnt Umber
- Phthalo Green
- Yellow Ochre
- Leaf Green
- Greenish Yellow
- Cadmium Red
- Emerald Green Nova
- Horizon Blue
- Cobalt Turquoise

PRIMING AND PREPARING THE CANVAS

1. Start by squirting a quarter of Raw Sienna acrylic paint onto the middle of the canvas. Use your palette knife like a shovel to rapidly spread large amounts of paint.

2. Use a damp sponge or paper towel to spread the rest of the paint from the center outward, to ensure an even, thin layer of paint. Don't forget to cover the sides of the canvas. (see detail above)

3. Now, you're going to draw the painting onto your canvas, starting with gridding out your canvas for accuracy. Use your T-square or ruler and No. 2 pencil to draw a grid of 48 squares that are 2 × 2 inches (5 × 5 cm) each—8 squares horizontally by 6 squares vertically. See "Gridding Out Your Canvas" on page 8 for additional instruction.

1.

2.

3.

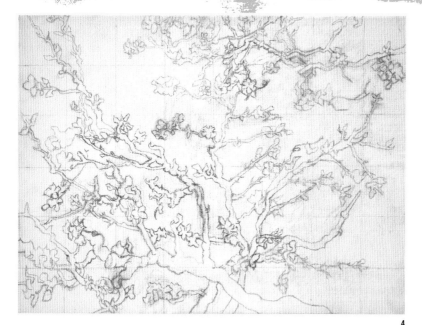

4.

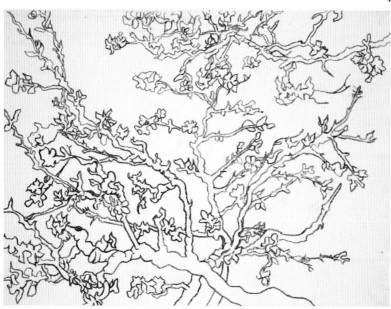

5.

4. Once your grid is prepared, it is essential to sketch an accurate drawing to use as your guide once you start painting. Use the Almond Blossom template on page 164 as your guide. You can either free-form sketch or trace the template. See "Drawing on Your Canvas" on page 9 for more instruction on how to use the template and your grid to make the drawing. Note: This is one of the most difficult drawings in the book, so you may want to do it in stages. Once you have the drawing down, the painting part is easy!

5. After completing the drawing, trace over the lines of the drawing (not the grid lines) with a Prismacolor marker. Now use your eraser to remove all the graphite pencil markings—both the drawing and the grid lines. Graphite will discolor the paint, so it is important to remove it. Don't worry about the marker—the thick lines of your Van Gogh painting will ensure that the marker is covered up. (see detail above)

NOTE: Though these images show a white canvas, your canvas will have been primed with the Raw Sienna acrylic paint.

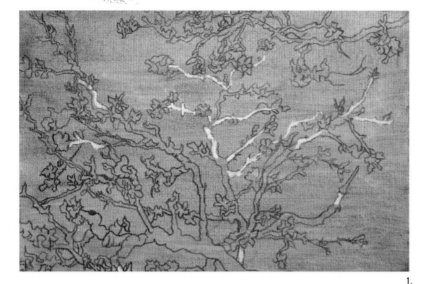

1.

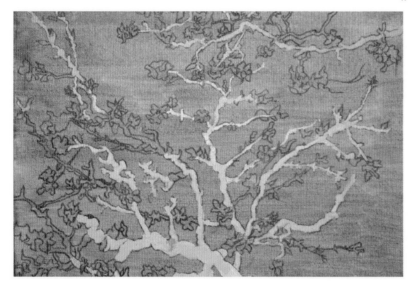

2.

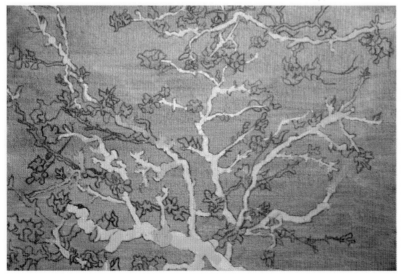

3.

PAINTING THE BRANCHES

Note: For this section, look closely at the reference photos for guidance as to which branches to paint.

1. Mix 3 quarters Titanium White and 1 pea Burnt Umber on your palette with a palette knife. To mix the paint using your palette knife, scoop, press, spread, and fold the paint together until it is thoroughly and evenly mixed. Reserve 1 quarter of the light branch mixture for later use. Using round brush no. 1, apply the paint to the large, thick branches near the bottom of the canvas. Switch to detail round brush no. 1 to apply the paint to the thinner branches around the canvas.

2. Mix 2 dots Phthalo Green into the remaining paint mixture from step 1 (not the quarter you reserved for later use) to make a gray-green mixture. Use flat brush no. 1 to fill in larger portions of the branches. Use a lot of paint for this step to add texture. Continue with the gray-green mixture, but switch to detail round brush no. 1 to paint the thinner branches in this color.

3. Mix ½ pea of the reserved Titanium White/Burnt Umber mixture from step 1 and ½ pea leftover gray-green mixture from step 2. After you have mixed these together, add 1½ peas Yellow Ochre and mix together. Use detail round brush no. 1 to fill in branches with this brownish color.

4. Mix 1 pea reserved Titanium White/ Burnt Umber mixture from step 1, ½ pea leftover gray-green mixture from step 2, and 1 dot Burnt Umber and mix together. Using detail round brush no. 1, paint some thin branches on the left side of the canvas.

5. Mix the remaining gray-green mixture from step 2 with 2 dots Phthalo Green and 2 peas Titanium White, then use detail round brush no. 1 to paint the remaining branches.

6. Before moving on to painting the flower blossoms and other details, use any leftover paint mixtures on your palette and your detail round brush no.1 to add more texture to the branches.

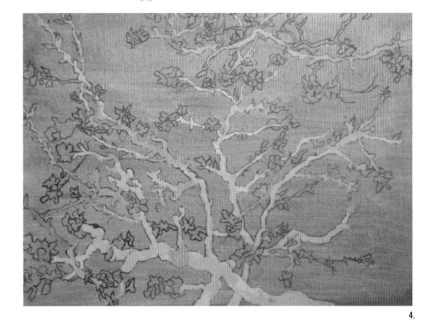

4.

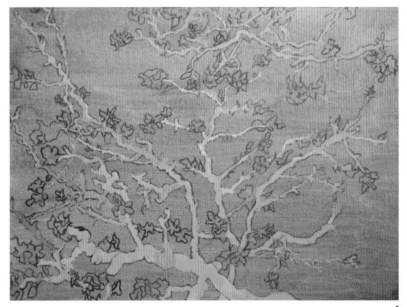

5.

PAINTING THE BLOSSOMS, LEAVES, AND DETAILS

1. Use 1 quarter Titanium White to paint the general shape of all of the blossoms; you will add colored paint and details later. Alternate between round brush no. 1 and detail round brush no. 1 depending on the size of the flower bud. If you accidentally pick up any of the branch color with your brush, wipe it off with a paper towel before reloading with Titanium White to avoid contaminating the colors.

2. With 1 pea Leaf Green and detail round brush no. 1, add yellow-green highlights to the centers of some of the flowers, allowing the Leaf Green to mix with the Titanium White on the canvas. Do not try to achieve one solid color, but rather keep the colors random.

3. Mix ½ pea each of Greenish Yellow and Titanium White. Use detail round brush no. 1 and this light green paint to create the base of the flower buds, where they connect to the branch, and the buds that have yet to bloom.

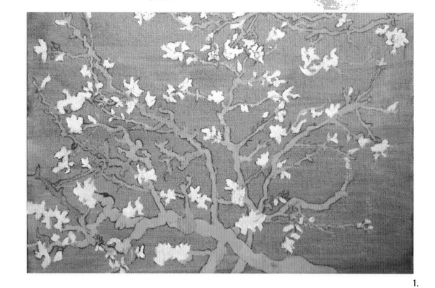

1.

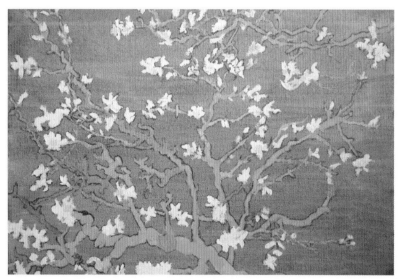

2.

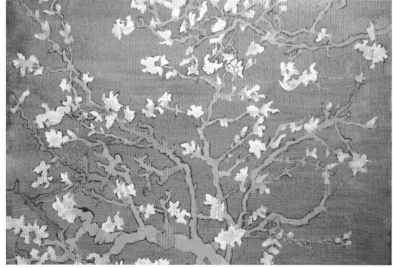

3.

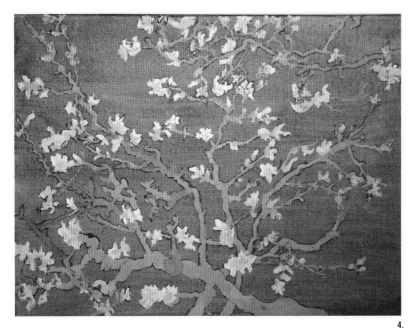

4.

4. Use ⅓ pea Cadmium Red and detail round brush no. 1 to add red details to the flowers and flower buds. Let some of the red paint interact with the Titanium White buds to get a pink color, but you also want some of the Cadmium Red to remain its original shade as a highlight. When mixing paint directly on the canvas, you aren't trying to achieve one solid color but a randomness that creates a painterly effect.

5. Use ½ pea Emerald Green Nova and detail round brush no. 1 to add green outlines to some of the flower petals and buds.

6. Use any remaining paint on the palette to add more texture to the branches, blossoms, or buds. When you are happy with the results, move on to painting the background.

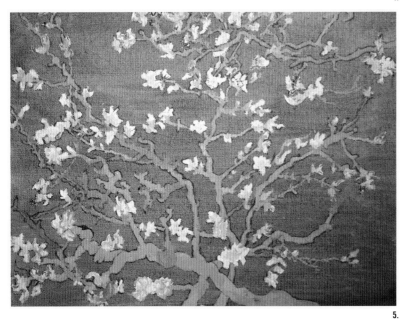

5.

1.

PAINTING THE BACKGROUND

1. With 3 quarters Horizon Blue and flat brush no. 4, begin painting the larger areas with thick horizontal strokes. Switch to flat brush no. 1 to fill in the smaller areas. In order to avoid contaminating the branches with the blue paint, line the edge of the brush up with the edge of the branches and pull the brush away from the branch. Don't worry if a little canvas peeks through between the background paint and the branches because you will be going back in to outline all of the branches later. Use all of the Horizon Blue on your palette.

2. Use 2 quarters Cobalt Turquoise to add the second and final layer to the background. Go back over the Horizon Blue from the previous step with the turquoise using flat brush no. 4 for larger areas and flat brush no. 1 for smaller areas. Allow the two colors to mix directly on the canvas, but also allow the Horizon Blue to randomly peek through in some areas. Use all of the Cobalt Turquoise on your palette. Look at the reference photo for guidance.

2.

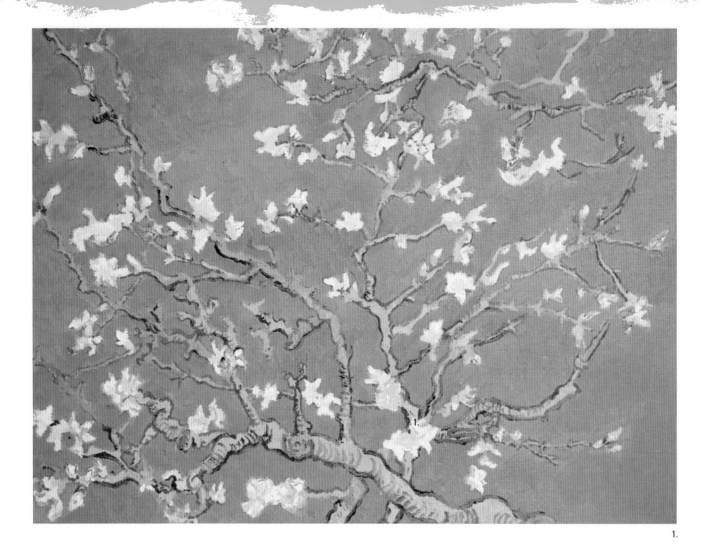

1.

PAINTING THE FINISHING TOUCHES

1. Use 2 peas Phthalo Green and detail round brush no. 1 to add detail lines and outlines to the branches for a barklike exterior. It's okay if the green mixes with the branch colors, but wipe your brush every so often to avoid completely contaminating the colors. Look at the reference photo for guidance.

2. You can also continue your painting around the edges of the canvas or paint them a solid color, especially if you're not planning on framing the painting. The painting will take three days to fully dry. Store it flat on a table until it is dry.

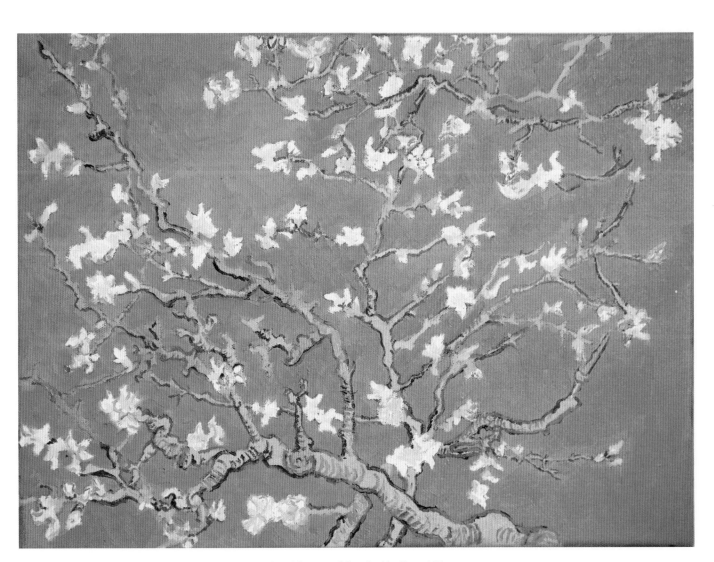

A completed forgery of Van Gogh's *Almond Blossoms*.

Irises

SAINT-RÉMY-DE-PROVENCE, FRANCE, MAY 1890

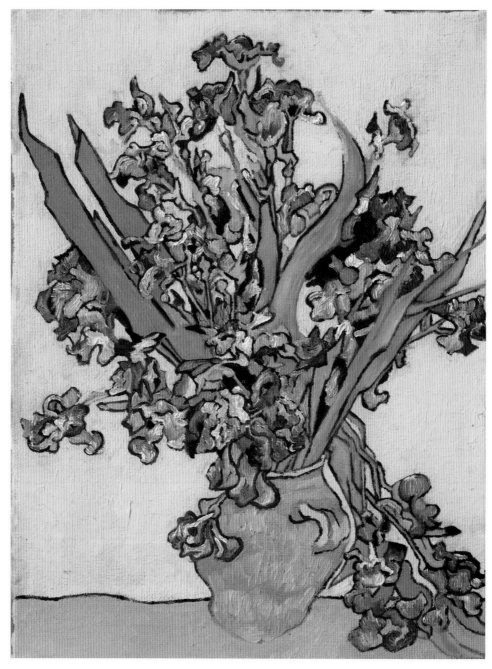

Irises, Van Gogh Museum, Amsterdam (Vincent van Gogh Foundation).

"The other violet bouquet (ranging up to pure carmine and Prussian blue) standing out against a striking lemon yellow background with other yellow tones in the vase and the base on which it rests is an effect of terribly disparate complementaries that reinforce each other by their opposition."

—Vincent van Gogh in a letter to his brother Theo van Gogh, May 1890

Van Gogh's still life of irises was painted while he was in the psychiatric hospital at Saint-Rémy in the last year of his life. During his stay he painted four bouquets of spring flowers, two of irises and two of roses. In this version of *Irises*, held by the Van Gogh Museum in Amsterdam, Van Gogh intended to show a strong color contrast between the dark purple flowers and the bright yellow background.

In the second *Irises* work, painted at the same time, now at the Metropolitan Museum of Art in New York, he wanted a softer effect and used pale violet against a pink background. When the French art critic Octave Mirbeau, the first owner of *Irises*, paid 300 francs for the painting, he said, "How well [Van Gogh] has understood the exquisite nature of flowers." Indeed, as today the painting is worth well in excess of $50 million.

For *Irises*, Van Gogh used the impasto technique, which involves applying the paint directly onto the canvas in very thick strokes that are often visible, using a brush or painting knife. The word impasto is from the Italian word meaning "dough" or "paste." Van Gogh's paintings took up to a month to dry, but when they did, the thick texture of the paint gave an almost three-dimensional, sculptural effect. The flowers in the painting were originally dark purple but over time they've faded to blue.

To achieve a similar dramatic effect as Van Gogh, you will use oil paint rather than watercolor and will mix the paint directly on the canvas.

Irises

MATERIALS

- 12 × 16-inch (30 × 40 cm) canvas (you can work on a flat surface or an easel)
- Holbein Heavy Body Artist Acrylic in Raw Sienna
- Palette knife
- Sponge or paper towel
- Ruler or T-square
- No. 2 graphite pencil
- Prismacolor marker in Light Pink
- Pink Pearl Eraser
- Palette or plastic plate
- Flat brushes (nos. 1, 4)
- Detail round brush (no. 1)

OIL COLORS

- Cadmium Yellow
- Lemon Yellow
- Titanium White
- Emerald Green Nova
- Ultramarine Light
- Prussian Blue
- Phthalo Blue
- Cadmium Yellow Hue
- Naples Yellow

PRIMING AND PREPARING THE CANVAS

1. to 3. Please refer to page 14.

4. Once your grid is prepared, it is essential to sketch an accurate drawing to use as your guide once you start painting. Use the Irises template on page 165 as your guide. You can either free-form sketch or trace the template. See "Drawing on Your Canvas" on page 9 for more instruction on how to use the template and your grid to make the drawing.

5. After completing the drawing, trace over the lines of the drawing (not the grid lines) with a Prismacolor marker. Now use your eraser to remove all the graphite pencil markings—both the drawing and the grid lines. Graphite will discolor the paint, so it is important to remove it. Don't worry about the marker—the thick lines of your Van Gogh painting will ensure that the marker is covered up.

NOTE: Though these images show a white canvas, your canvas will have been primed with the Raw Sienna acrylic paint.

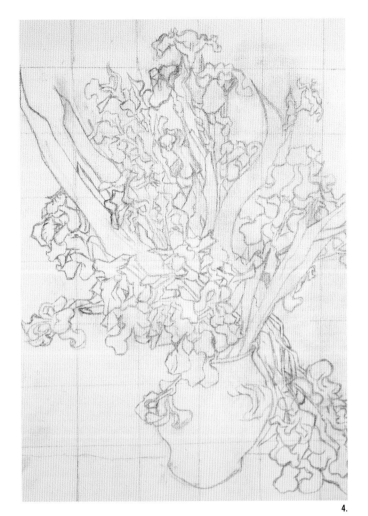

4.

5.

PAINTING THE
BACKGROUND AND LEAVES

1. Create the background color by mixing 2 peas Cadmium Yellow, 1½ quarters Lemon Yellow, and 1 quarter Titanium White on your palette with a palette knife. To mix the paint using your palette knife, scoop, press, spread, and fold the paint together until it is thoroughly and evenly mixed. Using flat brush no. 4, thickly paint the background of the painting. This is the area above the line for the table that is not a leaf, a flower, or the vase. Switch to flat brush no. 1 to paint smaller spaces, and for even tighter areas, such as in between petals, use detail round brush no. 1. Use lots of paint on your brushes to quickly build up the texture.

2. Put 1 pea Emerald Green Nova onto your palette. Use the entire pea to put a base layer of paint onto the leaves. Switch between flat brush no. 1 and detail round brush no. 1 depending on the size of area you're painting.

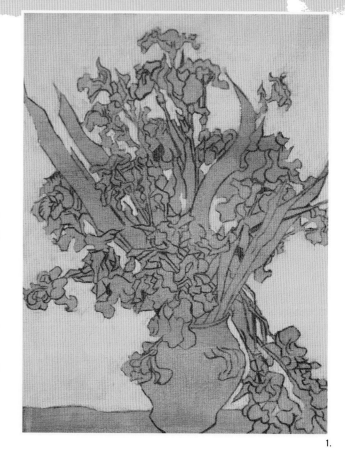

1.

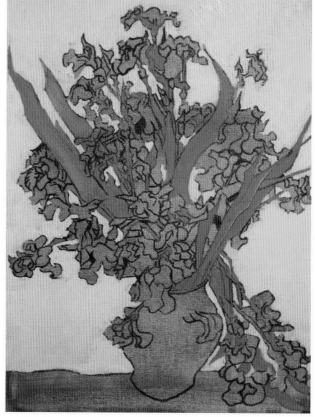

2.

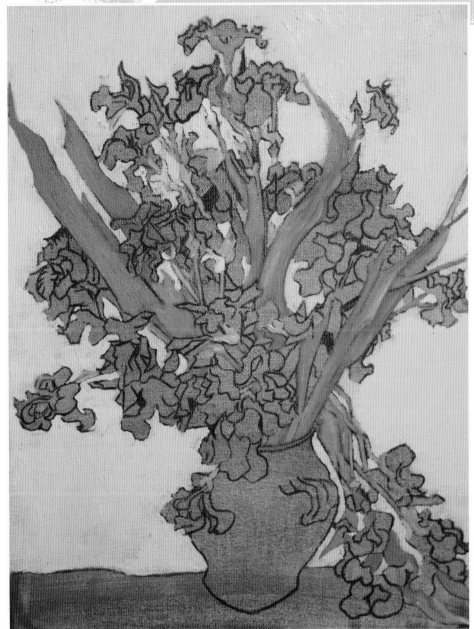

3. and 4.

3. Use 1 pea leftover yellow mixture from step 1 and detail round brush no. 1 to add highlights to the leaves. Allow the yellow to completely mix with the leaves' green layer, creating the light green of the leaf highlights. There should be no yellow paint on the leaves when you are done blending the colors. Look at the reference photo for guidance.

4. Use 1 pea Titanium White and detail round brush no. 1 to add more highlights to the leaves. Allow the white to completely mix with the leaves' green layer, creating a highlight. There should be no white paint on the leaves when you are done blending the colors, but neither do you want a uniform shade of green. Look at the reference photo for guidance.

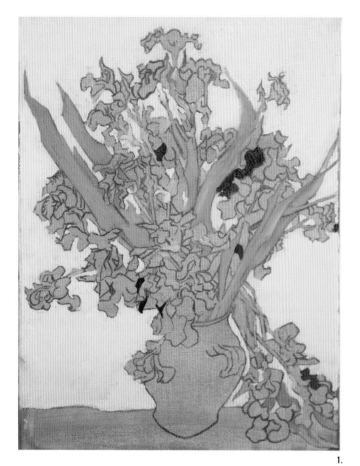

1.

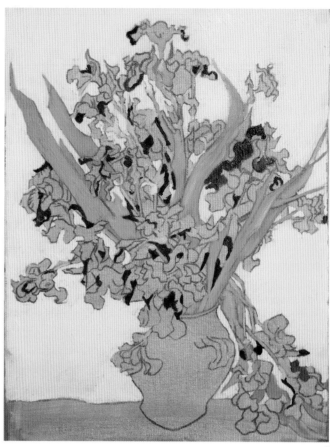

2.

PAINTING THE FLOWER PETALS

1. Use 1 pea Ultramarine Light and detail round brush no. 1 to begin painting the flower petals. Use a lot of paint to create texture and dimension in the flowers. This is the most vibrant blue we will use. Look at the reference photo to see which flowers should be painted with this color.

2. Use 1 pea Prussian Blue and detail round brush no. 1 to paint the darkest parts of the flowers. Again, use a lot of paint to create texture and dimension in the flowers. This is the darkest blue we will use. Look at the reference photo to see which flowers should be painted with this color.

3.

4.

3. Mix together 1 quarter Ultramarine Light and 1 quarter Phthalo Blue. Using this blue mixture and detail round brush no. 1, outline the leftmost flower by going over the guidelines from the drawing. Use a lot of paint on these lines because we will be pulling from them in the next step to create new colors.

4. Using ⅓ pea Titanium White and detail round brush no. 1, begin painting the petals of the flower you outlined in step 3. Allow your brush to pull blue paint from the outlines into the petals and mix directly with the white paint. This creates new shades of blue on each part of the flower, giving the painting texture and dimension. As long as there are different shades of blue throughout the flower, you will achieve the desired painterly effect. Go ahead and add a thick layer of fresh white paint to the areas of the flowers you want to highlight in white, as I did here with the center.

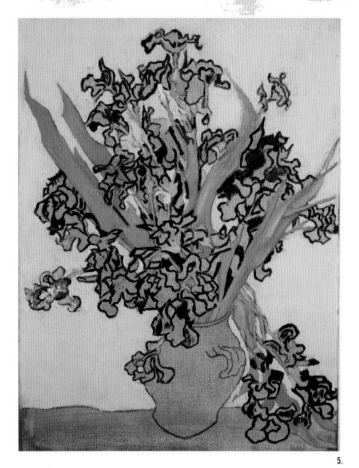

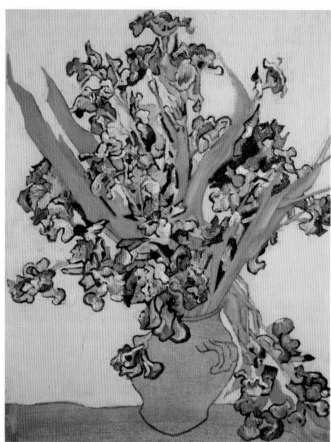

5.

6.

5. Using the blue mixture from step 3 and detail round brush no. 1, outline the remaining flowers by going over the drawn guidelines. Remember to use a lot of paint because you will be pulling paint from these areas in the next step to create new colors.

6. Using 1 quarter Titanium White and detail round brush no. 1, repeat the process of step 4 on the newly outlined flowers. Remember to create new shades of blue throughout, to add texture and dimension, and you can add fresh white paint to areas you especially want to highlight.

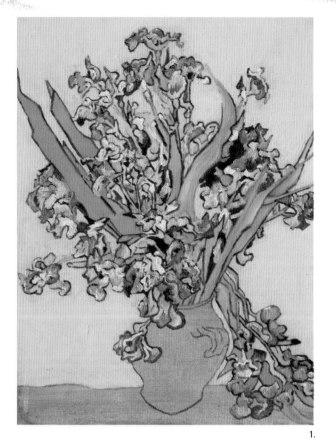

1.

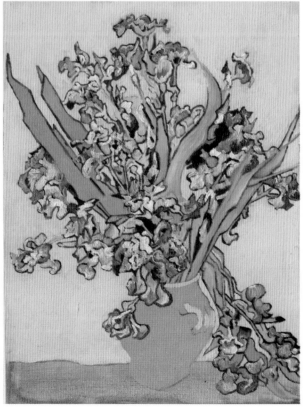

2. and 3.

PAINTING THE FINISHING TOUCHES

1. Use the leftover blue mixture (see step 3, "Painting the Flower Petals," page 30) and detail round brush no. 1 to outline the green leaves. Notice that I didn't entirely outline all of the leaves. Look at the reference photo for guidance.

2. Use 1½ peas Cadmium Yellow Hue and flat brush no. 1 to paint the vase. Paint it thickly to add texture. Do not paint the rim and front part of the handle, and avoid covering the drawn lines in those areas with paint.

3. Use ½ pea Naples Yellow and detail round brush no. 1 to paint the rim and front part of the handle of the vase. In addition, highlight the side of the handle with a couple of short strokes with the Cadmium Yellow paint.

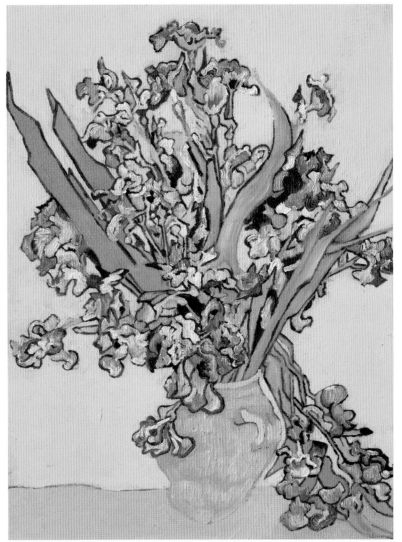

4. through 6.

4. Use 1 pea Naples Yellow and flat brush no. 1 to add texture to the vase. Make short vertical strokes to achieve the desired effect. Allow some of this color to mix in, but the majority of this paint should rest on the surface. Look at the reference photo for guidance.

5. Mix ⅓ pea Cadmium Yellow Hue and 1 pea Cadmium Yellow. Using flat brush no. 4, paint the table using broad horizontal strokes and lots of paint on the brush—this adds texture to the table area. To get into the smaller spaces on the right side of the canvas, switch to flat brush no. 1.

6. Use the leftover blue mixture (see step 3, "Painting the Flower Petals," page 30) and detail round brush no. 1 to outline the vase, including its rim and handle area. Also add the horizontal line separating the table from the wall. Notice that this line peeks through the drooping flowers on the right.

7. Use any remaining paint on your palette to add more of Van Gogh's signature texture. You can also continue your painting around the edges of the canvas or paint them a solid color, especially if you're not planning on framing the painting. The painting will take three days to fully dry. Store it flat on a table until it is dry.

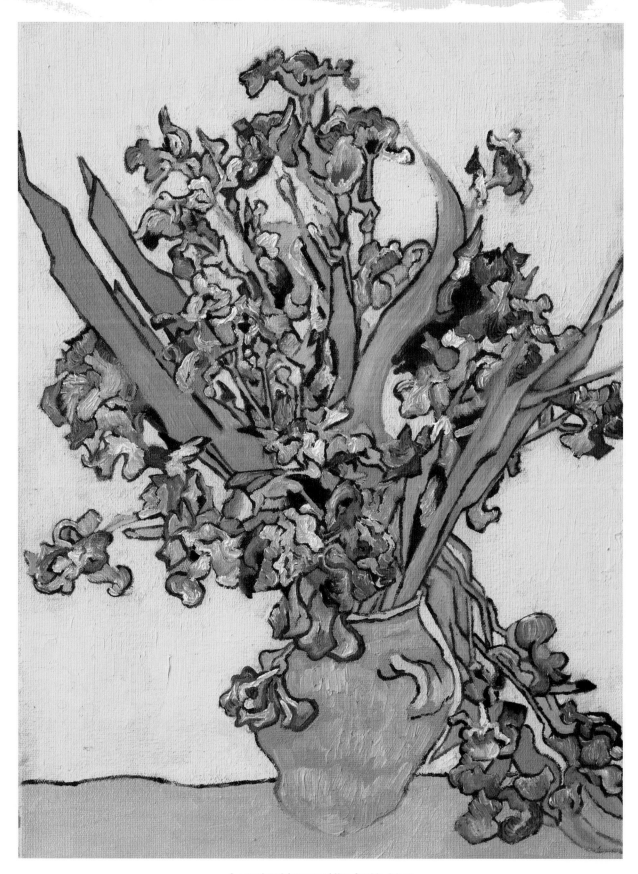

A completed forgery of Van Gogh's *Irises.*

Wheatfield with Crows

Auvers-sur-Oise, France, July 1890

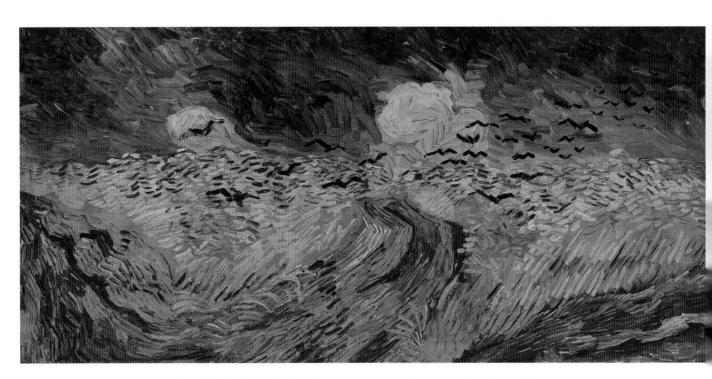

Wheatfield with Crows, Van Gogh Museum, Amsterdam (Vincent van Gogh Foundation).

"There—once back here I set to work again—the brush however almost falling from my hands and—knowing clearly what I wanted I've painted another three large canvases since then. They're immense stretches of wheatfields under turbulent skies, and I made a point of trying to express sadness, extreme loneliness."

—Vincent van Gogh in a letter to his brother Theo van Gogh and Theo's wife, Jo van Gogh-Bonger, July 1890

Even if the viewer wasn't aware that the artist shot himself in a wheat field in Auvers, France, and died two days later, this powerful landscape would still evoke feelings of foreboding. The symbols in the painting point in a direction of Van Gogh's mental state of despair and isolation. A menacing sky, a path that leads nowhere, and black crows all look ominous and have been widely interpreted as signs of Van Gogh's forthcoming suicide. In the 1956 Hollywood film *Lust for Life*, starring Kirk Douglas as Van Gogh, the final scene is of crows attacking before he shoots himself. However, while many critics have believed this was his last painting, that doesn't seem likely because it was painted several weeks before his death. Several paintings were made after this one and it's more probable that *Tree Roots*, an unfinished painting, was his final work. His brother Theo's brother-in-law Andries Bonger writes that "the morning before his death, he had painted an underwood, full of sun and life."

Van Gogh's use of strong colors and powerful brushwork creates a sense of movement. By the time of his death, color had become his main means of expression in his paintings. The blue sky contrasts strongly with yellow wheat fields and the green path. While the negative aspect of a path without an end and hovering black crows can't be overlooked, the color of the golden fields can be seen as a positive aspect of the painting. In 1884, Van Gogh wrote, "Summer is the contrast between blues and the orange tinge in the golden bronze of wheat."

Wheatfield with Crows

MATERIALS

- 16 × 12-inch (40 × 30 cm) canvas (you can work on a flat surface or an easel)
- Holbein Heavy Body Artist Acrylic in Raw Sienna
- Palette knife
- Sponge or paper towel
- Ruler or T-square
- No. 2 graphite pencil
- Prismacolor marker in Light Pink
- Pink Pearl Eraser
- Palette or plastic plate
- Flat brushes (nos. 1, 4)
- Round brush (no. 1)
- Detail round brush (no. 1)

OIL COLORS

- Cadmium Yellow
- Yellow Ochre
- Terra Rosa
- Yellow Green
- Leaf Green
- Emerald Green Nova
- Titanium White
- Greenish Yellow
- Phthalo Green Yellow Shade
- Ultramarine Light
- Phthalo Blue
- Indigo

PRIMING AND PREPARING THE CANVAS

1. to **3.** Please refer to page 14.

4. Once your grid is prepared, it is essential to sketch an accurate drawing to use as your guide once you start painting. Use the Wheatfield template on page 166 as your guide. You can either free-form sketch or trace the template. See "Drawing on Your Canvas" on page 9 for more instruction on how to use the template and your grid to make the drawing.

5. After completing the drawing, trace over the lines of the drawing (not the grid lines) with the Prismacolor marker. Now use your eraser to remove all the graphite pencil markings—both the drawing and the grid lines. Graphite will discolor the paint, so it is important to remove it. Don't worry about the marker—the thick lines of your Van Gogh painting will ensure that the marker is covered up.

NOTE: Though these images show a white canvas, your canvas will have been primed with the Raw Sienna acrylic paint.

4.

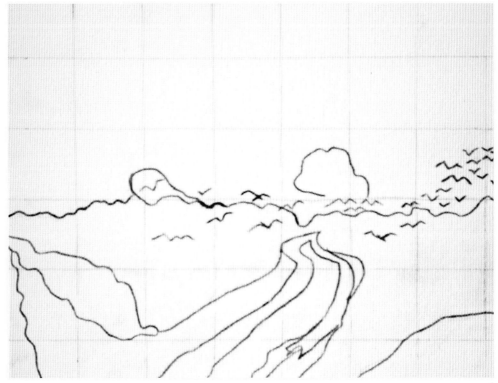

5.

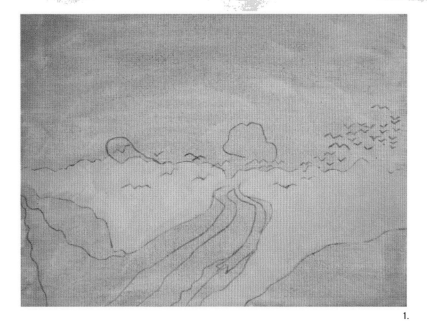

1.

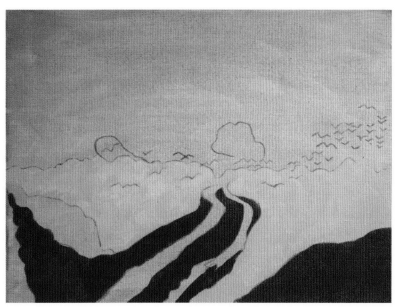

2.

STARTING THE WHEAT FIELD AND PATHWAYS

1. To create the mustard color for the wheat field, mix 1 quarter Cadmium Yellow with ½ quarter Yellow Ochre on your palette with a palette knife. To mix the paint using your palette knife, scoop, press, spread, and fold the paint together until it is thoroughly and evenly mixed. Using flat brush no. 4, paint the body of the wheat field. This is the base layer, so cover everything but don't paint it too thick. Fill in up to the edges with side-to-side strokes, but only paint in the outlined section. Save the leftover paint because you will use it later to build up texture.

2. Using 1½ peas Terra Rosa and flat brush no. 4, begin painting the pathway. Also use this to paint the lower-right corner of the canvas.

3. Mix 1 pea Yellow Green with 1 pea Leaf Green. Using flat brush no. 1, paint the base of the grassy areas between the paths and the area between the path and the wheat field. Save whatever paint is left over for later use.

3.

4. Using ½ pea Emerald Green Nova, paint the bottom-left corner of the canvas, from the edge of the canvas to the path.

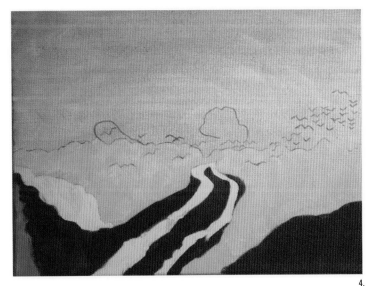

4.

5. Using flat brush no. 1, go back over the Emerald Green Nova from step 4 with ¼ pea leftover paint mixture from step 3, to lighten the dark green paint. Allow the colors to mix directly on the canvas.

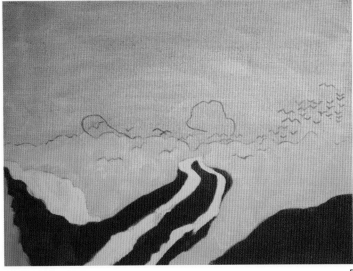

5.

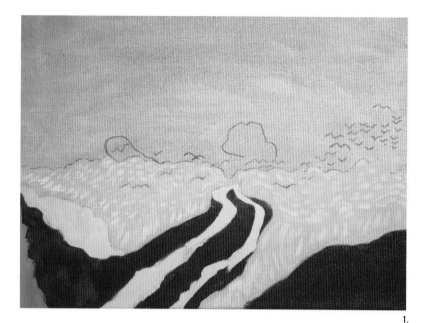

1.

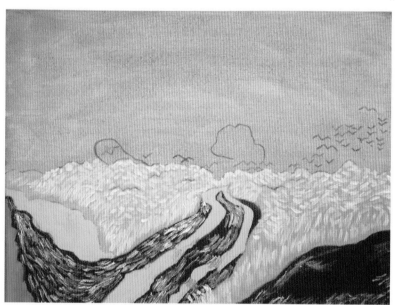

2. and 3.

TEXTURING THE FIELD AND PATHWAYS

1. Using round brush no. 1, paint 1 pea Cadmium Yellow in quick-moving strokes, starting at the lower edge of the field to define taller wheatgrass. Wipe your brush with a paper towel every three strokes so you don't contaminate the colors; a little mixing is okay, but you don't want to completely blend the colors. Next, switch to short horizontal strokes, or dashes, following the movement of the shape of the wheat field, above the vertical strokes. Keep these lines inside the boundaries of the field. Look at the reference photo for guidance.

2. Repeat both the vertical and the horizontal stroke movements of the previous step using 1 pea Titanium White and round brush no. 1. Switch to detail round brush no. 1 to add smaller, more defined grass and movement lines. Continue to wipe your brush with a paper towel every three strokes so you don't contaminate colors.

3. Using 1 pea Titanium White, add short brushstrokes to the path. Follow the directional movement of the roadway. Continue to wipe your brush with a paper towel every three strokes so you don't contaminate colors. Paint only the outside edges of the path in the lower-right corner with the white brushstrokes; we will add more color to this area later.

4. Use detail round brush no. 1 to add strokes of leftover paint mixture from the wheat field (see step 1, "Starting the Wheat Field and Pathways," page 40), Titanium White, and Cadmium Yellow to the path in the lower-right corner of the canvas. Layer the colors to build the texture and create a natural grass effect. Continue to wipe your brush with a paper towel every three strokes so you don't contaminate colors. Continue adding strokes of these colors and layer them to add more color and texture to this area as you progress. Look at the reference photos for guidance.

5. Using detail round brush no. 1 and 1 pea Emerald Green Nova, add some texture strokes, or dashes, to the grassy areas between the paths. Follow the directional movement of the roadway. Look at the reference photo for guidance.

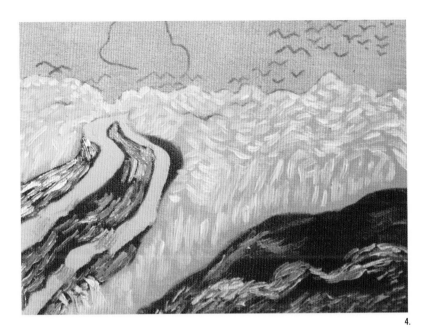

4.

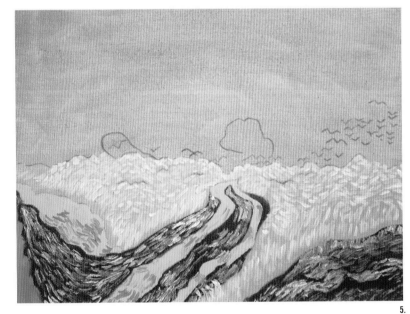

5.

6. Mix together ½ pea Greenish Yellow and ½ pea Phthalo Green Yellow Shade. Use detail round brush no. 1 and the reference photo to add dark dashes of texture to the green sections of the path. Continue to follow the directional movement of the roadway. Also add dark dashes to the darker green area in the lower-left corner of the canvas.

7. Use detail round brush no. 1 and the leftover paint mixture from the grassy areas between the paths (see step 4, "Starting the Wheat Field and Pathways," page 40) to go back over the dark green texture strokes painted in step 6. Allow some of the dark green texture to peek through. Look at the reference photo for guidance.

8. Add more texture to the green area in the lower-left corner by using ½ pea Emerald Green Nova and detail round brush no. 1. Move your brush in diagonal strokes across the area to match the directional movement of the path.

9. Use round detail brush no. 1 to layer in more dashes of the darkest green mixture from step 6. Then use detail round brush no. 1 and the lightest green mixture from step 4 to add some dashes to the Terra Rosa pathway.

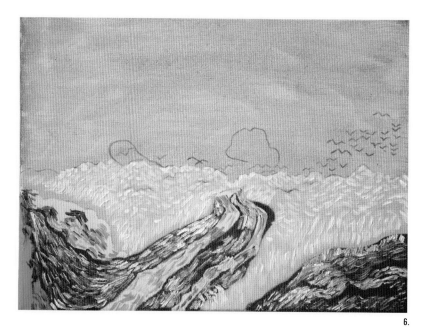

6.

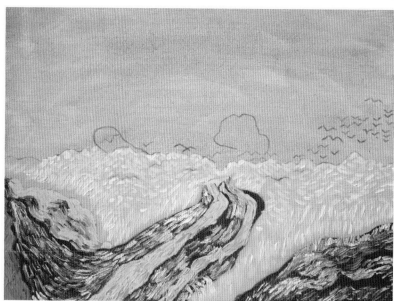

7. through 9.

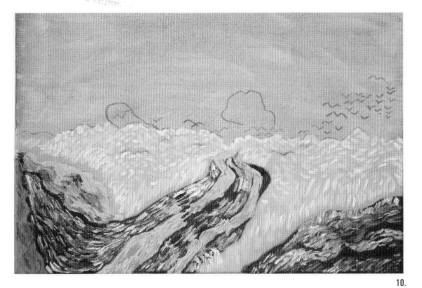

10.

10. Add ½ pea Terra Rosa to the road to create texture. Go over the areas of the road that are Terra Rosa with more of it to build up layers and create texture. Using a light touch (think of your brushstroke as gently placing the color on top of the layer beneath), also add some dashes of Terra Rosa over the grassy areas between the paths. You don't want the colors mixing on the canvas.

11. Using detail round brush no. 1 and ½ pea Cadmium Yellow, bring some wheatgrass into the left side of the left-hand Terra Rosa path. Using a light touch (like in step 10), avoid mixing these colors on the canvas—a little contamination is okay and adds to the painterly effect, but do not allow the colors to combine.

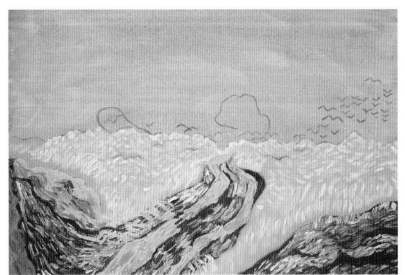

11.

12. Using detail round brush no. 1 and ½ pea Terra Rosa, add light, delicate strokes to the wheat field. Follow the directional movement, or waves, of the field. Look at the reference photo for guidance.

13. Use any remaining paint on the palette to go back over any areas of the field and paths that you feel need more texture or thickness. Wipe your brush with a paper towel to avoid contaminating the colors.

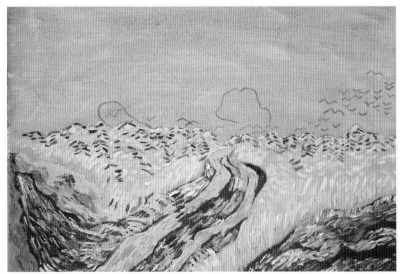

12.

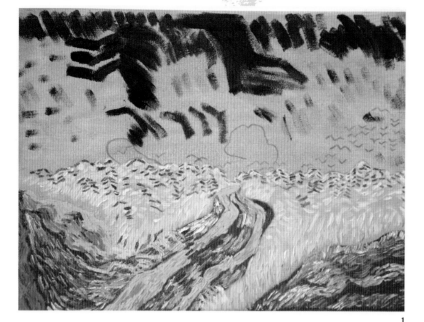

1.

PAINTING THE SKY

1. The sky is a stormy one and this is reflected through texture and color. Mix 2 peas Ultramarine Light and 2 peas Phthalo Blue. Using flat brush no. 1, add short, downward diagonal strokes across the top of the canvas. Extend some of these using large zigzags of directional movement, then fill in some of the remaining space with more sporadic dashes. Look at the reference photo for guidance.

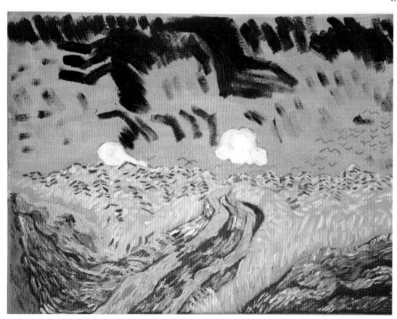

2.

2. Place 1 quarter Titanium White on your palette. Use flat brush no. 1 and some of the Titanium White (save leftover Titanium White for later use) to fill in both drawn clouds. Allow a dot of blue to contaminate the white as you paint them.

3. Use some leftover Titanium White and flat brush no. 1 and sweep the paint into the sky. Allow the white to mix with the blue that is already on the canvas. Do not allow the paint to completely mix, rather use the paint to create a mixture of light and dark areas. Add more Titanium White as necessary to achieve the desired effect.

4. Using flat brush no. 1 and the sky mixture from step 1, fill in more of the sky with the dark blue paint. The dark blue will mix somewhat with the lighter blue and the white paint, creating stormy patches of color in the sky. Look at the reference photo for guidance.

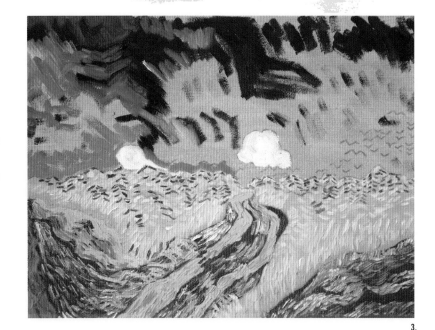

3.

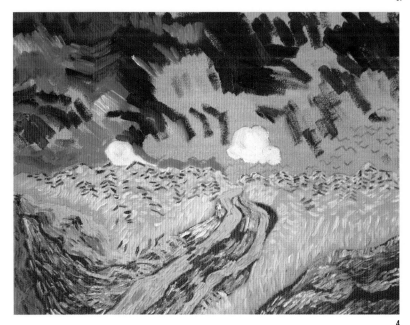

4.

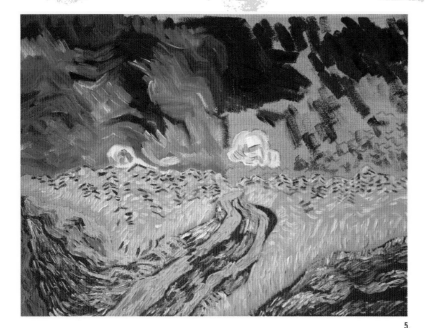

5.

5. Using flat brush no. 1 and leftover Titanium White, create brush patterns, following the jagged directional movements. Allow the white to mix with the blue on the canvas.

6. Continue to use flat brush no. 1 and alternate between Titanium White and the blue paint mixture to finish filling in the sky. Look at the reference photos for guidance.

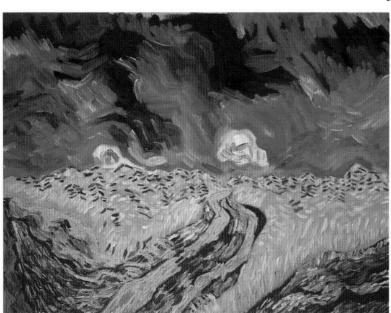

6.

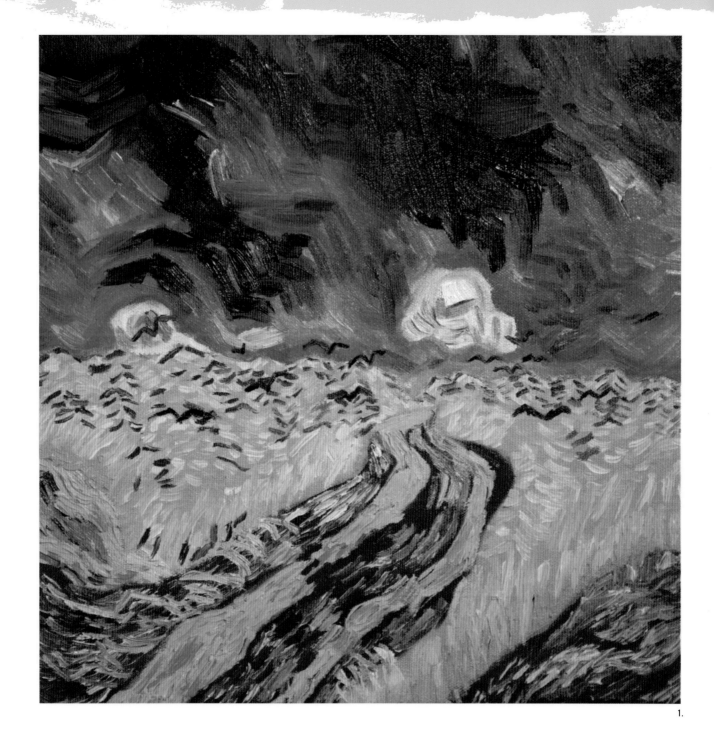

1.

PAINTING THE FLYING CROWS

1. Using detail round brush no. 1 and 1 pea Indigo, paint the crows at the horizon line on the sky and in the field. These larger crows are a wide-open M-shape—similar to how you may have learned to draw birds as a child—with curved wings and a sharp V at the center.

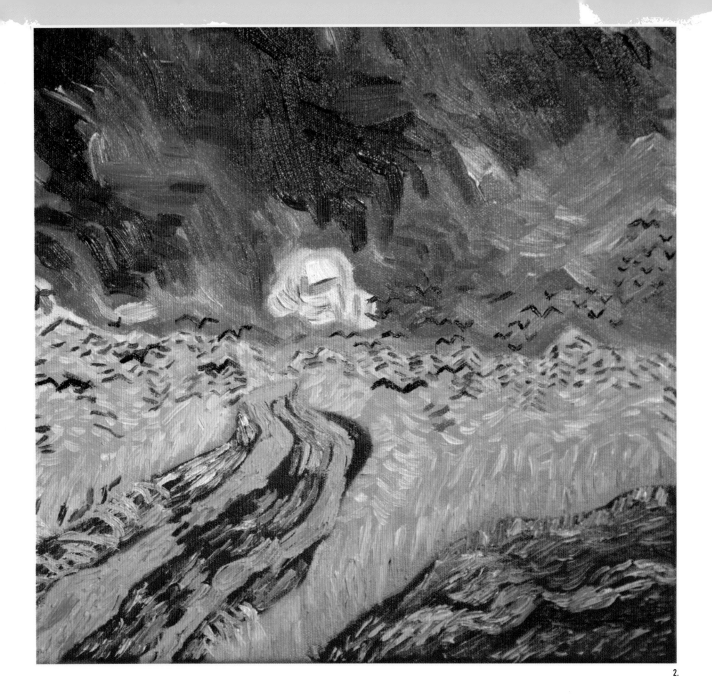

2.

2. Continue using detail round brush no. 1 and the Indigo paint and add the final crows going up the right side of the canvas. These crows should become smaller until they are only V-shapes as they fade into the distance.

3. Use any remaining paint on your palette to add more of Van Gogh's signature texture. You can also continue your painting around the edges of the canvas or paint them a solid color, especially if you're not planning on framing the painting. The painting will take three days to fully dry. Store it flat on a table until it is dry.

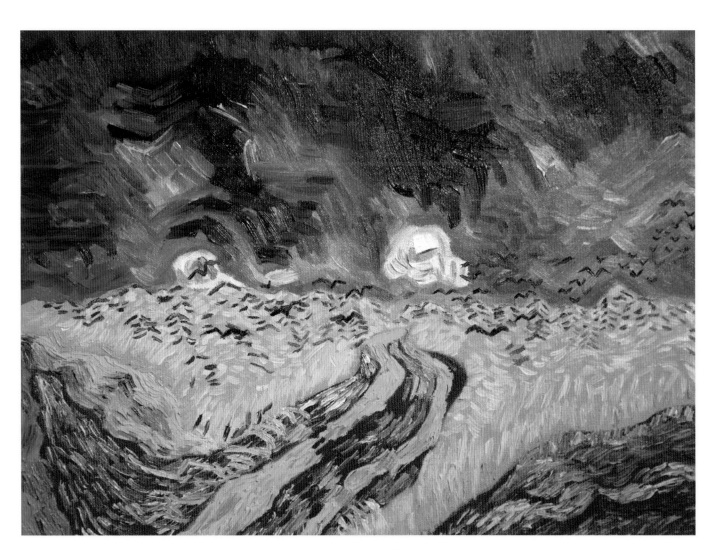

A completed forgery of Van Gogh's *Wheatfield with Crows*.

The Garden of Saint Paul's Hospital ("Leaf-Fall")

Saint-Rémy-de-Provence, France, October 1889

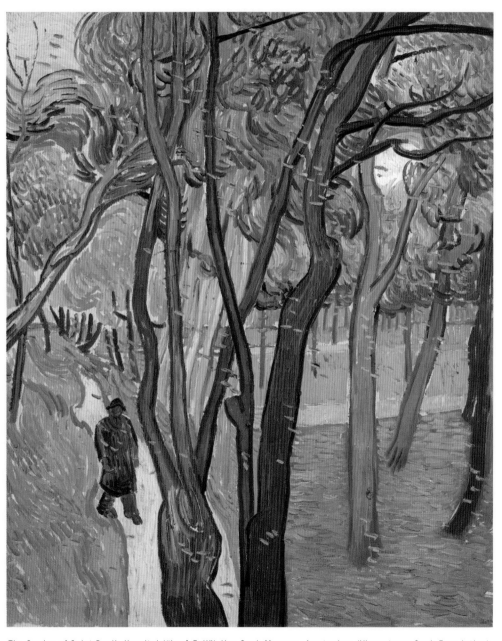

The Garden of Saint Paul's Hospital ("Leaf-Fall"), Van Gogh Museum, Amsterdam (Vincent van Gogh Foundation).

> "I feel happier with my work here than I could outside. By staying here a fairly long time, I'll have acquired controlled behavior, and in the long run the result will be more order in my life."

—Vincent van Gogh in a letter to his brother Theo van Gogh, June 1889

This painting was made about six months into Van Gogh's yearlong stay at the Saint Paul Asylum, where he'd voluntarily admitted himself, since renamed Clinique Van Gogh. Van Gogh had two small cells, one of which he used as a studio, and when he wasn't too ill, he drew inspiration from, and made paintings in, the asylum's garden. During his year in the asylum, he made over 150 paintings, including several that showed the changing seasons in the garden.

"Leaf-Fall" shows an autumn scene with the tall, bare tree trunks and the falling leaves. The dark browns, greens, and yellows further evoke the fall. The dark brown and black outlining of the tree trunks and branches shows the "Japonaiserie" technique, the term Van Gogh used for the influence of Japanese painting and printmaking on his work. The high viewpoint that shows the tops and trunks cut off by the upper and lower edges of the painting was a compositional technique borrowed from his fellow Post-Impressionist painters Paul Gauguin and Émile Bernard. The final group show of the Impressionists was in Paris in 1886, and although their techniques continued to influence artists, Van Gogh and his contemporaries were referred to as Post-Impressionists. The lone figure in the painting could be a gardener, other staff member, or perhaps Van Gogh himself.

Van Gogh described this painting as "The Fall of the Leaves." He recalled his youth in the Netherlands when he wrote to his brother, "Now that most of the leaves have fallen the landscape looks more like the north."

"Leaf-Fall"

MATERIALS

- 12 × 16-inch (30 × 40 cm) canvas (you can work on a flat surface or an easel)
- Holbein Heavy Body Artist Acrylic in Raw Sienna
- Palette knife
- Sponge or paper towel
- Ruler or T-square
- No. 2 graphite pencil
- Prismacolor marker in Light Pink
- Pink Pearl Eraser
- Palette or plastic plate
- Flat brushes (nos. 1, 4)
- Detail round brush (no. 1)
- Round brush (no. 1)

OIL COLORS

Titanium White
- Cobalt Blue
- Cerulean Blue
- Phthalo Blue
- Burnt Umber
- Cadmium Yellow Lemon
- Cadmium Green
- Yellow Green
- Yellow Ochre
- Prussian Blue
- Phthalo Green
- Quinacridone Gold
- Cadmium Orange
- Cadmium Red
- Burnt Sienna
- Cadmium Yellow
- Cadmium Yellow Hue
- Indigo
- Terra Rosa
- Leaf Green

PRIMING AND PREPARING THE CANVAS

1. to 3. Please refer to page 14.

4. Once your grid is prepared, it is essential to sketch an accurate drawing to use as your guide once you start painting. Use the "Leaf-Fall" template on page 167 as your guide. You can either free-form sketch or trace the template. See "Drawing on Your Canvas" on page 9 for more instruction on how to use the template and your grid to make the drawing.

5. After completing the drawing, trace over the lines of the drawing (not the grid lines) with a Prismacolor marker. Now use your eraser to remove all the graphite pencil markings—both the drawing and the grid lines. Graphite will discolor the paint, so it is important to remove it. Don't worry about the marker—the thick lines of your Van Gogh painting will ensure that the marker is covered up.

NOTE: Though these images show a white canvas, your canvas will have been primed with the Raw Sienna acrylic paint.

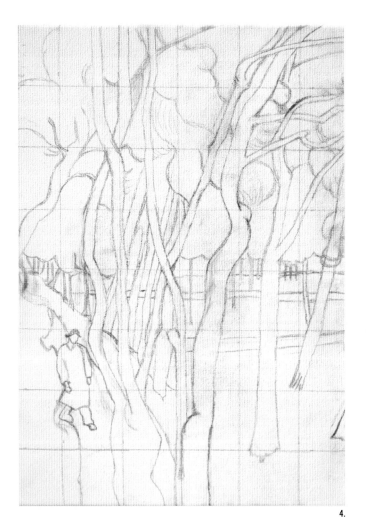

4.

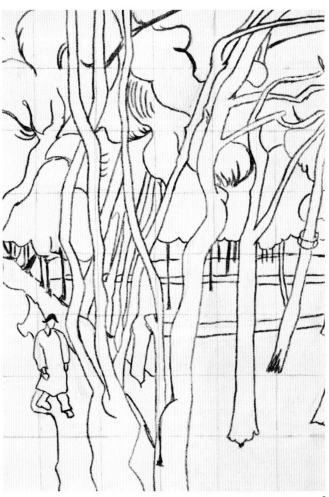

5.

1.

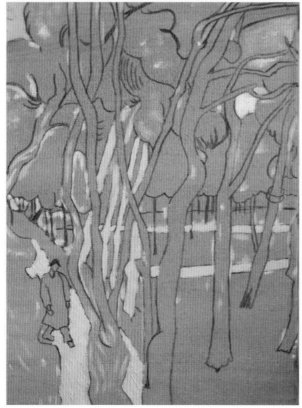

2.

PAINTING THE BACKGROUND

1. Place 2 peas Titanium White on your palette and use flat brush no. 4 to dry-brush the areas indicated on the reference photo.

2. Mix 1 quarter Titanium White, 1 dot Cobalt Blue, 1 dot Cerulean Blue, and 1 dot Phthalo Blue on your palette with a palette knife. To mix the paint using your palette knife, scoop, press, spread, and fold the paint together until it is thoroughly and evenly mixed. Use flat brush no. 1 and this light blue color to paint in the walkways and four tree trunks in the background, the patch of sky in the upper left-hand corner of the canvas, and the walkway in the foreground of the painting. Look at the reference photo for guidance.

3. Mix 1 dot Cerulean Blue and 1 dot Phthalo Blue with the remaining light blue paint mixture from step 2. Use detail round brush no. 1 and this darker shade of blue to outline the four tree trunks that you painted in the previous step.

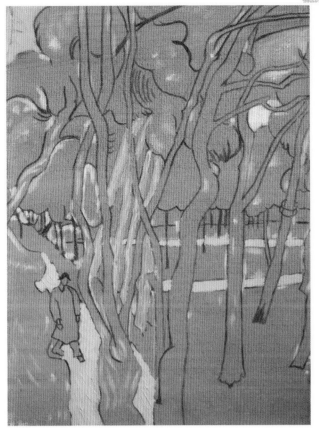

3.

Forgery Tip

How to dry-brush? Don't paint thick layers, but rather paint gently in small amounts with a dry paintbrush. The resulting paint strokes will have a characteristically scratchy appearance.

PAINTING THE LAWN

1. Mix 2 peas Titanium White with ½ pea Burnt Umber to create a beige color. Using flat brush no. 4, dry-brush this color onto the foreground and treetops. Look at the reference photo for guidance.

2. Using flat brush no. 4 and 1 pea Cadmium Yellow Lemon, dry-brush the area along the left-side walkway and the lawn in the right-hand foreground.

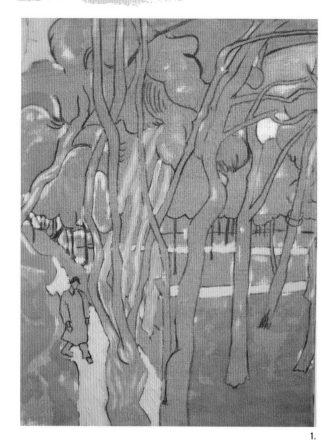

1.

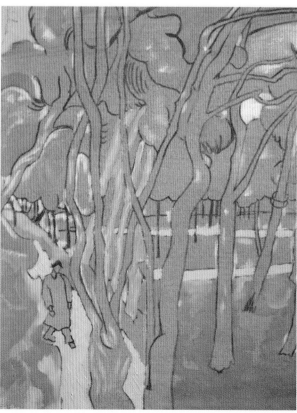

2.

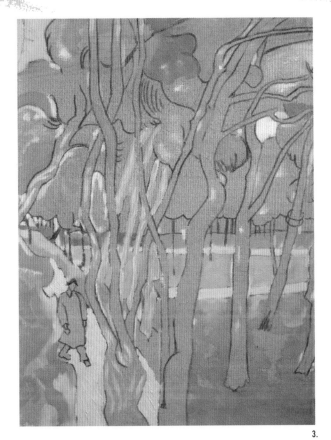

3.

3. Mix ½ pea Cadmium Green with ½ pea Yellow Green to create a vibrant green for the lawn. Use flat brush no. 4 and horizontal strokes to paint this into the two green lawn areas in the center and background. Also use this color to paint the treetops in the top center and on the upper-right side of the canvas (use the reference photo as guidance). Switch to flat brush no. 1 for any small spaces that flat brush no. 4 cannot reach. When you are done, mix 1 dot Cadmium Green into the leftover paint and go back over the tree and darker parts of the lawn.

4. Mix the leftover beige paint mixture from step 1 with 1 pea Titanium White, 1 pea Yellow Ochre, ⅓ pea Burnt Umber, and 1 dot Phthalo Blue. Alternating between flat brush no. 4 (for larger areas) and flat brush no. 1 (for smaller spaces), paint most of the remaining treetops in the upper half of the canvas. Be sure not to cover the marker lines. Look at the reference photo for guidance.

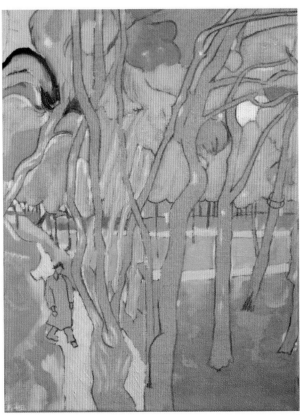

4.

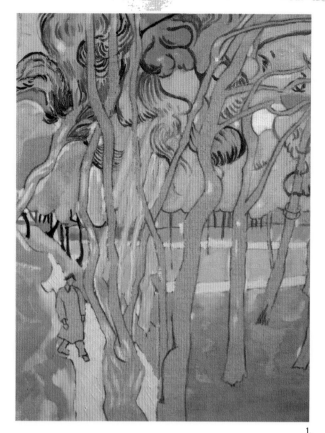

1.

PAINTING THE TREETOPS

1. Mix 1 pea Prussian Blue with 1 pea Phthalo Blue. Using detail round brush no. 1, add thin line details to the treetops. These lines dictate the directional movement of the leaves. Also paint the distant, dark blue tree trunks on the left side of the canvas and the tree trunks farthest in the background on the right side of the canvas. Refer to the drawing lines and reference photo for guidance.

2. Mix ½ pea of the light beige paint mixture (see step 4, "Painting the Lawn," page XX), 1 dot Phthalo Green, and 1 dot Phthalo Blue. Using flat brush no. 1 and the resulting teal color, paint in the treetops, above tree trunks outlined in light blue. Also paint this color in the top-right corner of the painting. Look at the reference photo for guidance.

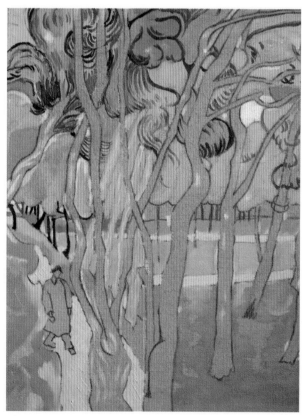

2.

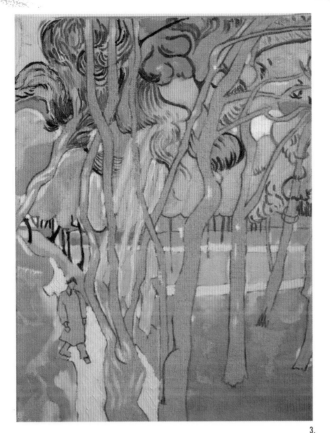

3.

3. Mix ½ pea Quinacridone Gold with 2 peas Cadmium Orange. Using detail round brush no. 1 and the resulting orange color, add the swirling line details to the treetops in the upper left, upper right (near where you just painted teal), and near the horizon line on the right side. Look at the reference photo for guidance.

4. Mix ½ pea Cadmium Red with ½ pea Burnt Sienna. Using detail round brush no. 1, add dark red swirling lines and short dashes to the treetops (use the reference photo for guidance). Outline the drawn vertical line in the upper-left corner with this color, too.

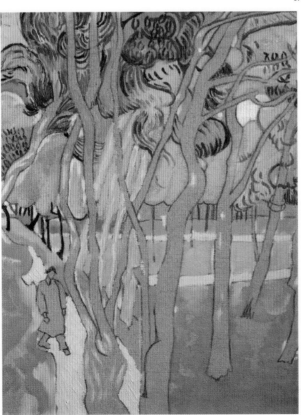

4.

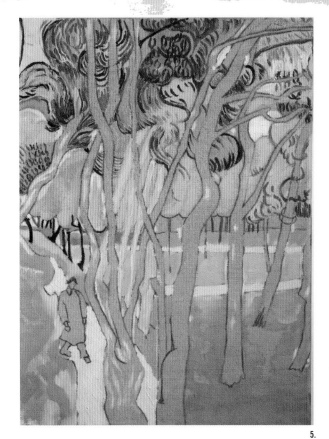

5.

5. Using detail round brush no. 1 and Titanium White, add more line detail between some of the tree branches in the upper-right corner of the canvas. Also use leftover blue mixture from step 1 in this section (page 60) to add in blue lines here.

6. Put 1 pea each of Cadmium Yellow, Cadmium Yellow Hue, and Cadmium Yellow Lemon on your palette WITHOUT mixing them together. Using detail round brush no. 1, alternately swirl these three shades of yellow onto the bottom row of treetops. Some blending is good, but wipe your brush with a paper towel between each color change to avoid making one uniform color. Also add a touch of the orange mixture from step 3 in this section (page 61) to swirl into the far right and center of the treetops. Look at the reference photo for guidance.

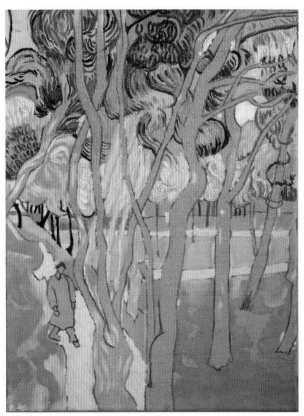

6.

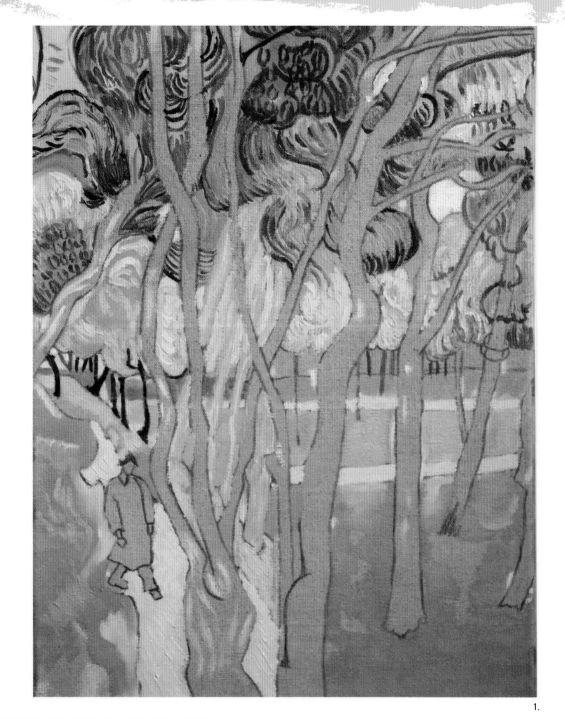

1.

PAINTING THE DETAILS OF THE LAWN

1. Using detail round brush no. 1 and ½ pea Cadmium Yellow Hue, paint diagonal strokes on the lawn to the left of the main walkway (use the reference photo for guidance). Switch to flat brush no. 1 and ½ pea Cadmium Yellow to fill in the area of the lawn to the right of the walkway and to paint the five dashes of Cadmium Yellow in the upper-left corner of the canvas.

2. Use the leftover orange mixture (see step 3, "Painting the Treetops," page 61) and detail round brush no. 1 to outline the right side of the main path and the upper-left side. Also add some orange highlights to the Cadmium Yellow from the previous step on both sides of the walkway, along with painting horizontal dashes (leaves) onto the beige lawn in the lower-right side of the canvas. Look at the reference photo for guidance.

3. Use leftover red paint mixture (see step 4, "Painting the Treetops," page 61) and detail round brush no. 1 to add short diagonal strokes to the left side of the walkway. Look at the reference photos for guidance.

4. Use leftover dark green mixture (see step 3, "Painting the Lawn," page 59) and detail round brush no. 1 to add short, vertical dashes to the bottom-left corner of the canvas.

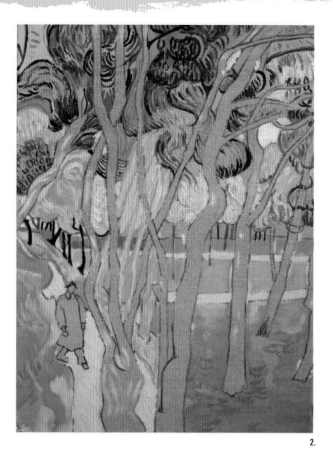

2.

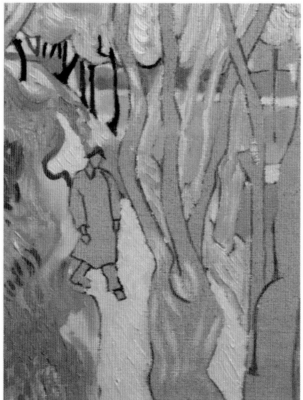

3. and 4.

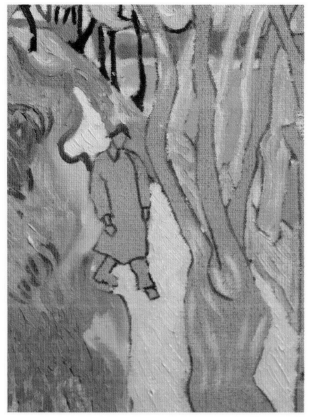

5. and 6.

5. Use the remaining dark blue paint mixture (see step 1, "Painting the Treetops," page 60) and detail round brush no. 1 to add three swirling line details to the upper-left lawn.

6. Add a dot of Indigo to ¼ pea of the beige paint mixture (see step 1, "Painting the Lawn," page 58) to create a dark gray. Use detail round brush no.1 to fill in the top of the main walkway with this mixture.

7. Now you're going to add fallen leaves to the front section of the lawn. Start with detail round brush no. 1 and add horizontal dashes of leftover red paint mixture (see step 4, "Painting the Treetops," page 61) along the right side of the tree trunk in the center of the canvas. Wipe your brush with a paper towel and use any remaining Cadmium Yellow Lemon to add dashes of yellow to the right side of the lawn (also fill in some of the space near the lower-left corner of the canvas, between the path and the lawn). Then wipe your brush and use ⅓ pea Yellow Green to add dashes to the upper part of the right side of the lawn. Look at the reference photo for guidance.

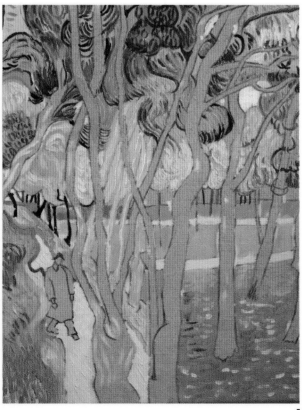

7.

1.

2.

PAINTING THE TREE TRUNKS

1. Use 1 pea Burnt Sienna and flat brush no. 1 to fill in the trunk and branches of the center-right tree in the foreground. Also lightly brush Burnt Sienna onto the base of the trunk and upper-right branches of the tree just to the left.

2. Mix 2 peas Titanium White, ½ pea Burnt Sienna, 1 dot Burnt Umber, and 1 dot Cadmium Red to create a peachy brown color. Using flat brush no. 1, paint the far-left tree trunk that juts in from the left side of the canvas. Fill in the trunk and branches of the center-left tree in the foreground. Also paint the tree trunk second from the right in the front section of the lawn. Switch to detail round brush no. 1 and sweep the peachy brown over the Burnt Sienna of the tree trunk in the center right of the foreground. Do not make another solid layer of color; just add lines at random to create the texture of bark. Look at the reference photo for guidance.

3.

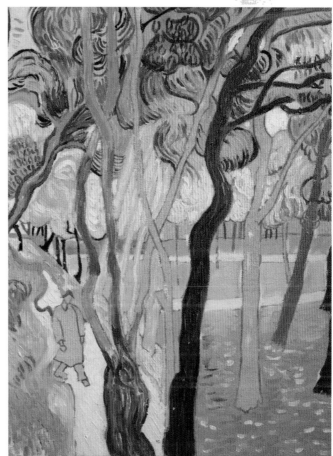

4.

3. Put ½ pea Terra Rosa on your palette. Start with flat brush no. 1 and fill in the tree trunk on the far right side of the canvas. Switch to detail round brush no. 1 and outline the tree trunk on the far-left side of the canvas. Use the rest of the Terra Rosa paint and detail round brush no. 1 to sweep the paint over the trunks of the center-front trees. Again, do not make another solid layer of color, but just add lines at random to create the texture of bark.

4. Use some of the remaining shades of brown paint and Cadmium Yellow Hue to layer the paint on the branches of the center-left tree in the foreground with detail round brush no. 1. Look at the reference photo for guidance.

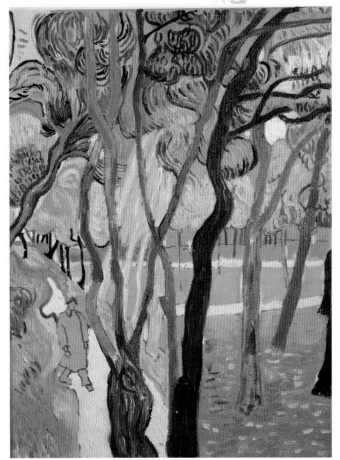
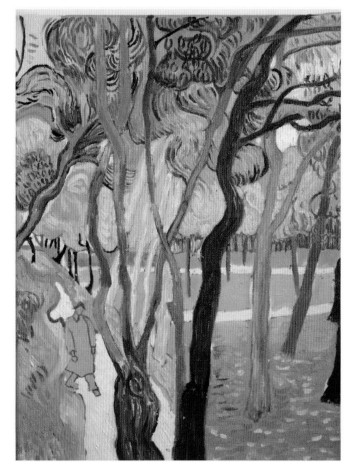

5. and 6. 7.

5. Use ½ pea Leaf Green and round brush no. 1 to paint the two thin trees jutting out from the center-front trees and the remaining unpainted tree on the right side of the lawn. Look at the reference photo for guidance.

6. With detail round brush no. 1 and leftover brown shades and Yellow Ochre, layer these colors onto the green tree trunks you painted in step 5. Alternate the colors to add layers and wipe your brush periodically. Look at the reference photo for guidance.

7. Use ¼ pea Yellow Green and detail round brush no. 1 to slightly lighten and blend the green tree trunks. Wipe your brush with a paper towel to avoid contaminating colors, and then use detail round brush no. 1 and leftover brown mixtures to fill in the horizon area between the lawn and the yellow treetops.

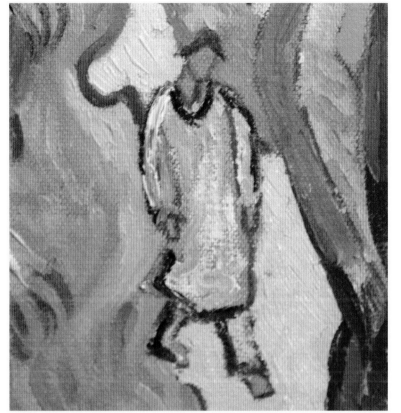

1. and 2.

PAINTING THE WALKING MAN

1. Use ¼ pea Titanium White and flat brush no. 1 to lightly fill in parts of the walking man's coat and pants. Do not cover the guidelines—you still need to be able to see them. Use a dot of Phthalo Blue to begin shading the man's coat.

2. With ¼ pea Indigo and detail round brush no. 1, outline parts of the man's outfit. Look at the reference photo for guidance.

3. Mix ¼ pea Phthalo Blue with the remaining Indigo on your palette. Use detail round brush no. 1 to add more layers of blue in downward strokes to the coat, pants, and shoes. Also paint his hat.

4. Use the remaining peachy brown mixture (see step 2, "Painting the Tree Trunks," page 66) and detail round brush no. 1 to fill in the man's face, neck, and hands. Use the blue paint mixture from the previous step to roughly outline his neck and face.

3. and 4.

1. and 2.

PAINTING THE FINISHING TOUCHES

1. Put 1 pea Terra Rosa and ½ pea Burnt Umber onto your palette WITHOUT mixing them together. Use detail round brush no. 1 and the reference photo to outline the tree trunks and branches using these colors. The Burnt Umber is the darkest brown in the reference photo.

2. Use 1 pea Indigo and detail round brush no. 1 to outline the remaining tree trunks.

3. Use any remaining paint on your palette to add more of Van Gogh's signature texture. You can also continue your painting around the edges of the canvas or paint them a solid color, especially if you're not planning on framing the painting. The painting will take three days to fully dry. Store it flat on a table until it is dry.

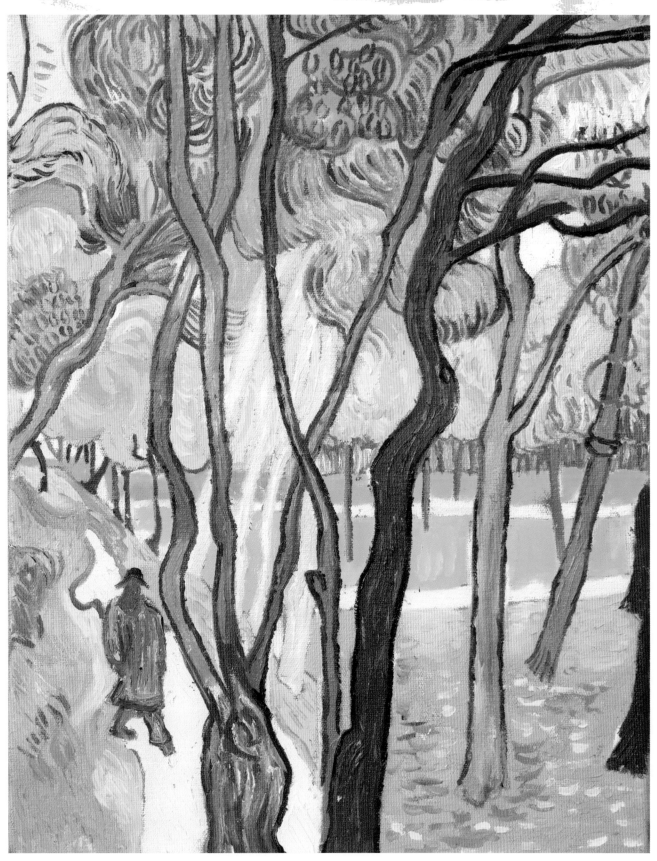

A completed forgery of Van Gogh's *The Garden of Saint Paul's Hospital ("Leaf-Fall")*.

Sunflowers

ARLES, FRANCE, 1889

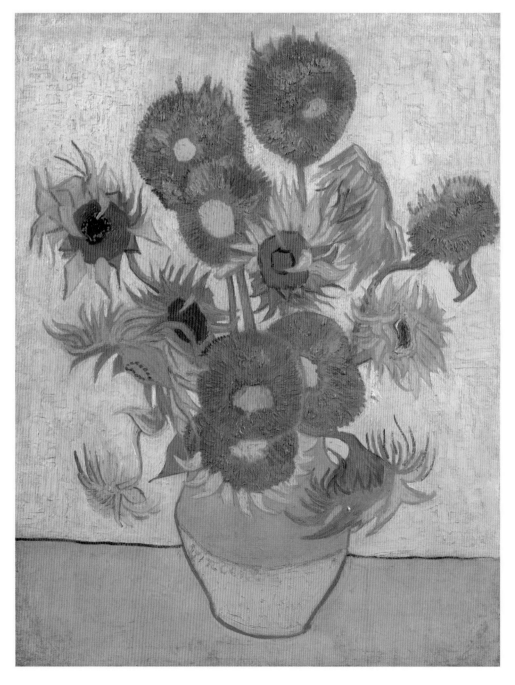

Sunflowers, Van Gogh Museum, Amsterdam (Vincent van Gogh Foundation).

> "At the moment I'm working on a bouquet of twelve sunflowers in a yellow earthenware pot and have a plan to decorate the whole studio with nothing but sunflowers."

—Vincent van Gogh in a letter to his sister Willemien van Gogh, August 1888

Van Gogh made two series of paintings with sunflowers as the subject. The first series, painted in Paris in 1887, show the flowers on the ground; the second, better-known series depict the flowers in a vase and were painted in Provence in southern France.

Van Gogh started his now famous sunflower paintings in anticipation of his fellow painter Paul Gauguin's arrival at the "Yellow House" in Arles, France, in 1888. The paintings were intended as a welcome and a sign of respect to his houseguest, an admired figure in the avant-garde art movement in Paris. The two artists collaborated in the Provençal studio throughout the fall of 1888, but all was not well, and by the end of the year, Van Gogh had a nervous breakdown, cut off part of his ear, and was admitted to an insane asylum. Self-mutilation does seem most probable, although two German art historians have recently claimed that Gauguin cut off Van Gogh's ear during a sword fight.

The still lifes of the sunflowers, in simple earthenware pots, demonstrate an impressive range of techniques, from tiny pointillist dots to thick strokes. The paintings also show that Van Gogh broke with some of the rules of the popular Impressionist movement of the day, especially their color theories. Van Gogh used color in his sunflower paintings to express emotion rather than to precisely depict nature. In a letter to Theo, his art dealer brother, Van Gogh wrote, "It is a kind of painting that rather changes in character, and takes on a richness the longer you look at it."

Gauguin was impressed with Van Gogh's final sunflower paintings, asking for one as a gift and telling Theo van Gogh that they were "a perfect example of a style that is completely Vincent." Gauguin's tribute to Van Gogh's genius can be seen in *The Painter of Sunflowers*, his portrait of Van Gogh that he produced toward the end of their ill-fated house share.

Van Gogh planned to produce twelve sunflower paintings to decorate the walls of the yellow house in Provence, but in the end he painted a quartet, three of which are still in existence (one was destroyed in a bombing raid in Japan in World War II) and on display in various museums around the world, including London's National Gallery, Amsterdam's Van Gogh Museum, and the Philadelphia Museum of Art. In 1987, nearly a hundred years after his death, one of Vincent van Gogh's paintings of sunflowers sold at a record auction price of £24,750,000 ($83 million). Not long afterward, reproductions of the painting appeared on cards, posters, and more, making the image and the artist a household name.

Sunflowers

MATERIALS

- 12 × 16-inch (30 × 40 cm) canvas (you can work on a flat surface or an easel)
- Holbein Heavy Body Artist Acrylic in Raw Sienna
- Palette knife
- Sponge or paper towel
- Ruler or T-square
- No. 2 graphite pencil
- Prismacolor marker in Light Pink
- Pink Pearl Eraser
- Palette or plastic plate
- Flat brushes (nos. 1, 2, 4)
- Round brush (no. 1)
- Detail round brush (no. 1)

OIL COLORS

- Lemon Yellow
- Titanium White
- Cadmium Yellow
- Burnt Sienna
- Jaune Brillant
- Cadmium Yellow Hue
- Yellow Ochre
- Cadmium Yellow Lemon
- Cadmium Yellow Light Hue
- Quinacridone Gold
- Cadmium Orange
- Terra Rosa
- Burnt Umber
- Phthalo Green Yellow Shade
- Greenish Yellow
- Yellow Green
- Cadmium Green
- Emerald Green Nova
- Leaf Green
- Cobalt Blue

PRIMING AND PREPARING THE CANVAS

1. to 3. Please refer to page 14.

4. Once your grid is prepared, it is essential to sketch an accurate drawing to use as your guide once you start painting. Use the Sunflowers template on page 168 as your guide. You can either free-form sketch or trace the template. See "Drawing on Your Canvas" on page 9 for more instruction on how to use the template and your grid to make the drawing.

5. After completing the drawing, trace over the lines of the drawing (not the grid lines) with a Prismacolor marker. Now use your eraser to remove all the graphite pencil markings—both the drawing and the grid lines. Graphite will discolor the paint, so it is important to remove it. Don't worry about the marker—the thick lines of your Van Gogh painting will ensure that the marker is covered up.

NOTE: Though these images show a white canvas, your canvas will have been primed with the Raw Sienna acrylic paint.

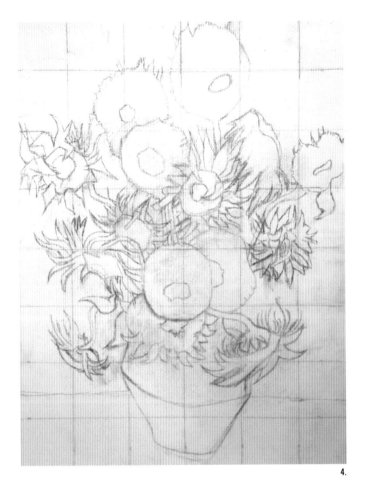

4.

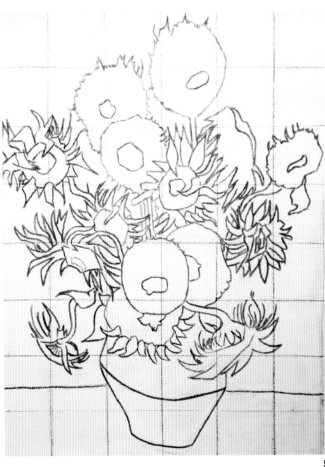

5.

PAINTING THE BACKGROUND

1. Create the background color by mixing 3 quarters Lemon Yellow and 1 quarter Titanium White on your palette with a palette knife. To mix the paint using your palette knife, scoop, press, spread, and fold the paint together until it is thoroughly and evenly mixed. Using flat brush no. 4, paint the background. Notice that Van Gogh's painting has a cross-hatched texture in the background, so be sure to alternate vertical and horizontal strokes. Switch to flat brush no. 2 to go right up to the edges of the drawing.

2. Using 1 quarter Cadmium Yellow and flat brush no. 4, paint the table. Use a lot of paint and make the texture of the table really thick. Switch to flat brush no. 2 to go right up to the edges of the drawing.

3. Use 1 pea Burnt Sienna and flat brush no. 2 to paint the horizontal line between the table and the background. Use the flat end to your advantage to keep the line completely straight. Avoid pushing down hard and hold the brush so the tip of it is positioned to paint a horizontal line. I suggest painting from left to right and adding more paint to the brush as necessary. Try to keep the line thickness the same from left to right, but Van Gogh's line has some variance in paint thickness, so it's okay if it varies slightly.

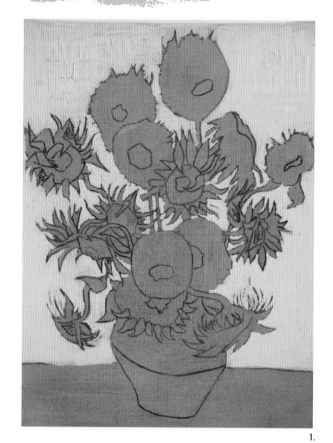

1.

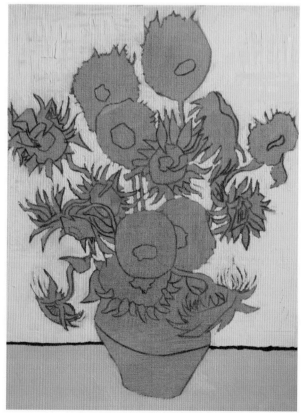

2. and 3.

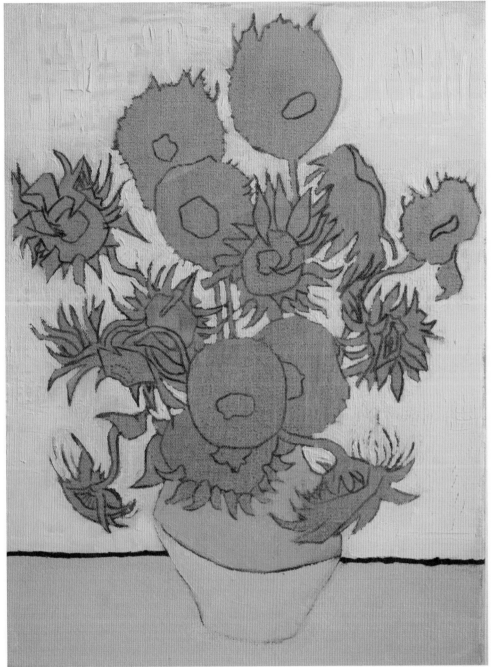

1. and 2.

PAINTING THE VASE

1. Using 2 peas Jaune Brillant and flat brush no. 2, paint thick lines on the lower part of the vase.

2. Use 2 peas Cadmium Yellow Hue and flat brush no. 2 to paint the upper part of the vase. Paint thick lines so that it creates texture. Go right up to the edges of the drawing.

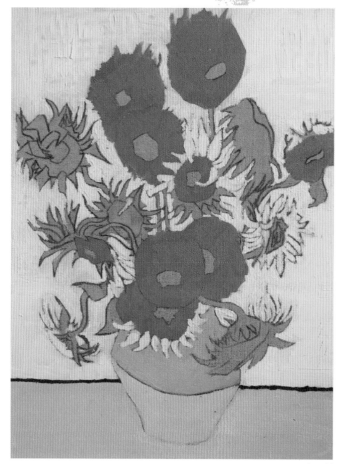

1. and 2.

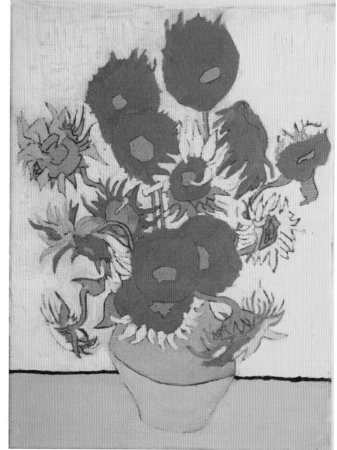

3. and 4.

PAINTING THE FLOWERS

Note: For this section, look closely at the reference photos for guidance as to which flowers and parts of the flowers to paint.

1. Use 2 quarters Yellow Ochre and flat brush no. 4 to paint the outer center of each sunflower. Switch to flat brush no. 1 to get into the small areas. Keep this coat thin because you will add texture and depth to these areas later.

2. Use 1 quarter Cadmium Yellow Lemon and sweeping strokes to paint the light yellow petals of the flowers.

3. Use the remaining Yellow Ochre paint from step 1 and round brush no. 1 to fill in the darkest petals.

4. Use 1 pea Cadmium Yellow Light Hue and round brush no. 1 to paint the majority of the long wispy petals. Switch to flat brush no. 1, if it is easier, to paint the zigzag edge of the flower in the upper left. Also use Cadmium Yellow Light Hue and round brush no. 1 to add a highlight to the drooping bottom-right flower.

5. and 6.

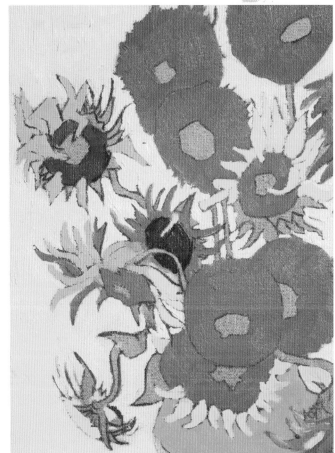

7. and 8.

5. Focus on the upper-left flower and the one diagonally below it. You are going to layer paint on both flowers to get a painterly effect. Use ½ pea Quinacridone Gold and flat brush no. 1 to paint the outer center of the upper-left flower and the center of the lower flower.

6. Use ¼ pea Cadmium Orange and flat brush no. 1 to paint the lower three-quarters of the upper-left flower's outer center, allowing the Cadmium Orange to mix directly with the Quinacridone Gold on the canvas.

7. Use ¼ pea Terra Rosa and flat brush no. 1 to paint the center of the lower flower. Mix the Terra Rosa directly into the Quinacridone Gold on the canvas. Repeat this step with ¼ pea Cadmium Orange.

8. Use ⅓ pea Yellow Ochre and flat brush no. 1 to add a little more depth to the outer center of the upper-left flower that was painted in step 6. Add another layer of Terra Rosa to the center of the lower flower.

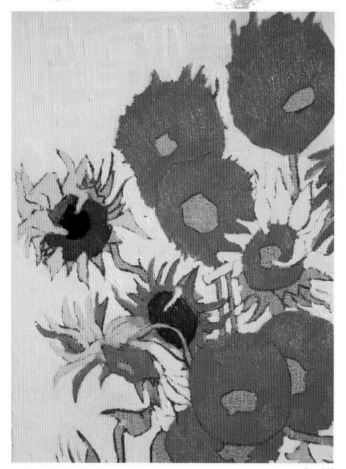

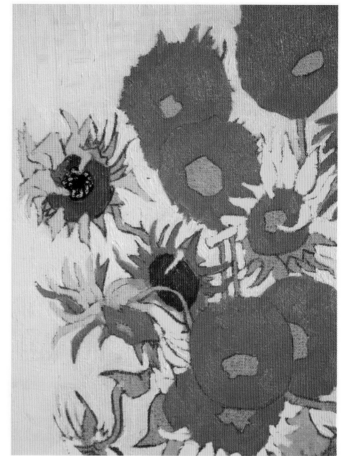

9. and 10.

11. and 12.

9. Put 1 pea Yellow Ochre onto your palette. Use ¼ of this pea and flat brush no. 1 to paint the top quarter of the upper-left flower's outer center (the part with Quinacridone Gold only). Switch to detail round brush no. 1 and add a swoop of Burnt Sienna to the right side of the new Yellow Ochre layer.

10. Use ¼ pea Burnt Umber and flat brush no. 1 to fill in the flower's dark center.

11. Put ¼ pea Cadmium Yellow Hue on your palette. Use detail round brush no. 1 to stipple yellow dots onto the flower's dark center. Use a lot of paint for these dots, but wipe your brush every couple of dots to avoid contaminating the colors.

12. Use leftover Yellow Ochre and detail round brush no. 1 to add texture and depth to the orange part (lower three-quarters) of the flower's outer center.

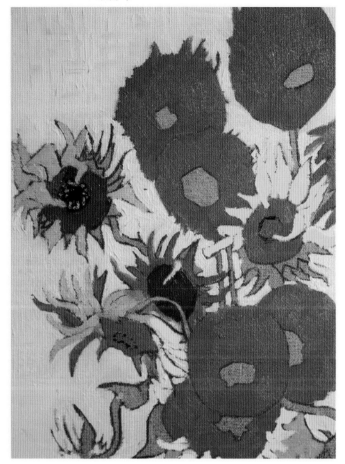

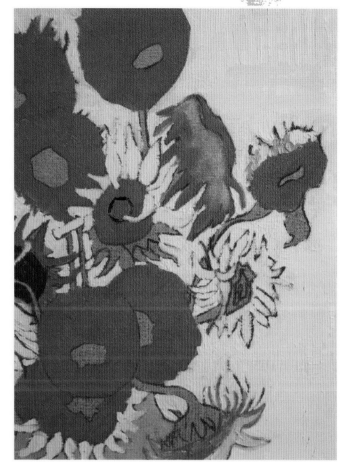

13. through 15.

16.

13. Now focus on the flower directly underneath the upper-left flower, which is drooping down. Use ¼ pea Yellow Ochre and flat brush no. 1 to paint the center of the flower.

14. Put ¼ pea Phthalo Green Yellow Shade on your palette. Use this color and detail round brush no. 1 to stipple a circular dot pattern in the center of the flower. Wipe your brush every couple of dots to avoid contaminating the colors.

15. Now focus on the flower in the center of the painting with the yellow petals on top. Use detail round brush no. 1 to paint the center of the flower with ¼ pea Yellow Ochre. Use leftover Phthalo Green Yellow Shade and detail round brush no. 1 to add the green circular detail around the flower's center. This circle is a solid line.

16. Now paint the sunflower with its center facing the upper-right corner of the canvas. Use ¼ pea Cadmium Yellow Light Hue and flat brush no. 1 to lightly brush highlights onto it. It's okay if this layer isn't perfect because you will be covering it with another, more detailed layer.

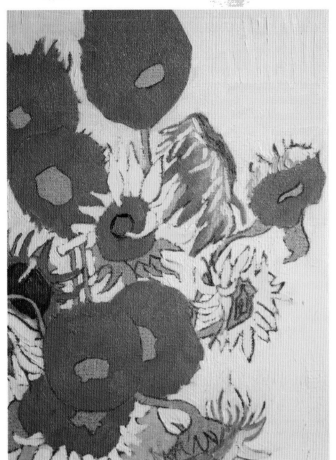

17.

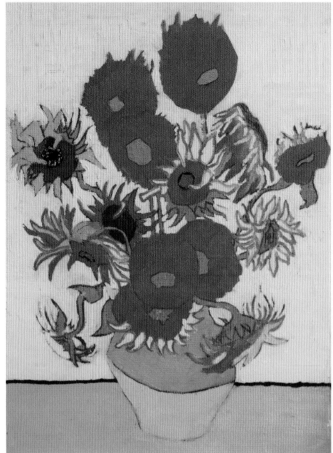

18.

17. Use ½ pea Cadmium Yellow Lemon and detail round brush no. 1 to add the details of the petals. Make thin lines of the yellow color, but leave them far enough apart so that they are distinct. Wipe your brush between each line detail so the color of the petals remains bright and vibrant, rather than becoming contaminated. Use the remaining Quinacridone Gold and detail round brush no. 1 to fill the flower's center.

18. Using 2 peas Yellow Ochre and detail round brush no. 1, outline the already painted petals on all of the flowers.

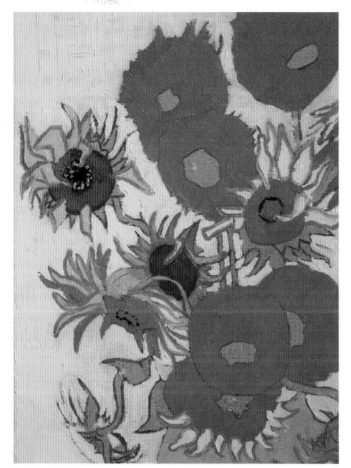

19.

20.

19. Mix 1 pea Cadmium Yellow Hue with 2 dots Cadmium Orange. Use the yellow-orange mixture and detail round brush no. 1 to line the yellow petals of the upper-left flower. Using leftover paint, add the Yellow Ochre lines to some of the petals on this flower. Finally, outline the flower's center with ⅓ pea Burnt Umber.

20. Focus on the flower farthest to the right. Using the yellow-orange mixture from step 19 and detail round brush no. 1, add touches of this color to the tips of the petals.

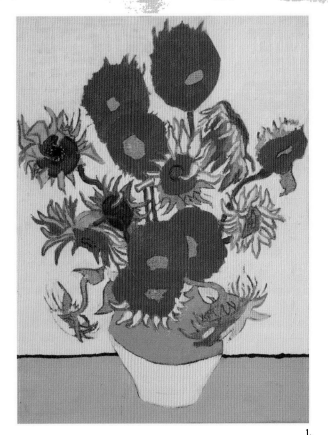

1.

PAINTING THE STEMS AND LEAVES

1. Use 1 pea Greenish Yellow and flat brush no. 1 to paint the first layer of the stems. Do not paint the stems of the flowers drooping at the bottom. Look at the reference photo for guidance.

2. Use 1 pea Yellow Green and detail round brush no. 1 to layer over the stems you painted in step 1.

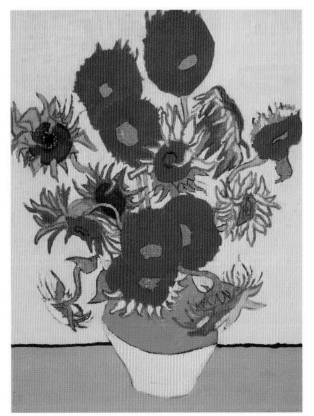

2.

Forgery Tip

In this section, you will be layering on paint to get the desired painterly effect and color. It's okay if the paint colors mix; however, you do not want a completely solid outcome. It's nice to have different greens randomly peeking through.

3. Now focus on the middle flower with the upright yellow petals. Using leftover Greenish Yellow paint from step 1 in this section and flat brush no. 1, fill in the flower's lower leaves.

4. Using leftover Yellow Green and detail round brush no. 1, fill in the leaves of the flower you just painted, the flower to its left and diagonally below it, and the bottom leaf of the upper-left flower. Look at the reference photo for guidance.

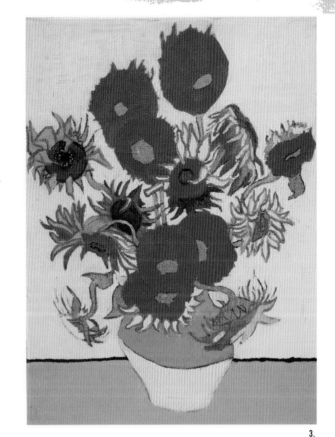

3.

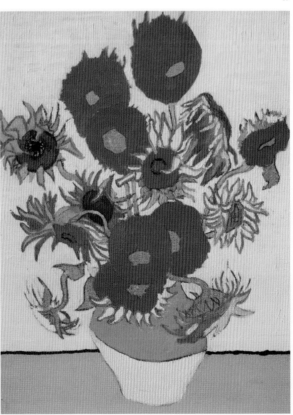

4.

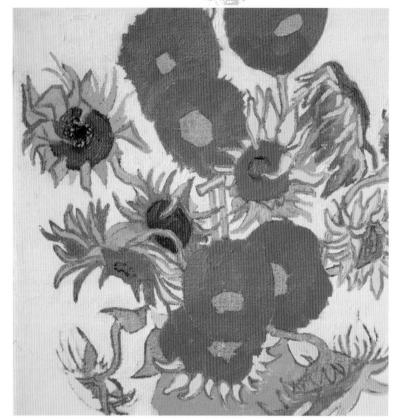

5. and 6.

5. Put 1 pea Cadmium Green and 1 pea Emerald Green Nova on your palette, but do NOT mix them. Using detail round brush no. 1, outline the painted flower stems in Cadmium Green, then add a few Emerald Green Nova lines to the upper-left and upper-right flowers. Look at the reference photo for guidance.

6. Using the remaining Emerald Green Nova paint from step 5 and detail round brush no. 1, paint the remaining leaves of the upper flowers. Look at the reference photo for guidance.

7. Using the remaining Cadmium Green from step 5 and detail round brush no. 1, outline the necessary Emerald Nova leaves of the upper-left flower in dark green. Look at the reference photo for guidance on which leaves need to be outlined.

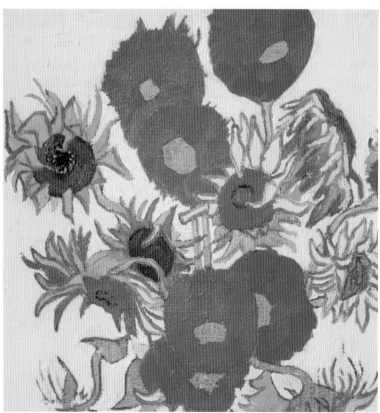

7.

8. Focus on the flower facing the upper-right corner of the canvas. Using ⅓ pea Leaf Green and detail round brush no. 1, add two leaves to the lower part of the flower. Look at the reference photo for guidance.

9. Now focus on the lower stems and leaves. Using ½ pea Greenish Yellow and flat brush no. 1, add a base layer of green paint to the leaf behind the bottom-center flower and to the stem and underside of the bottom-right flower. Look at the reference photo for guidance.

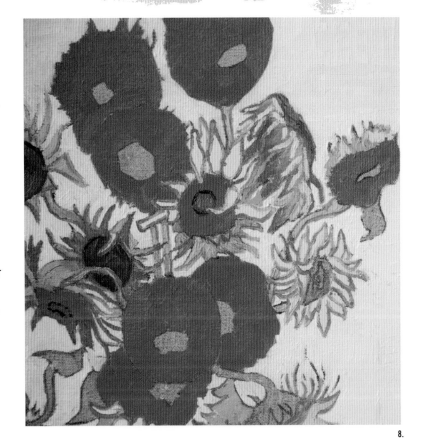

8.

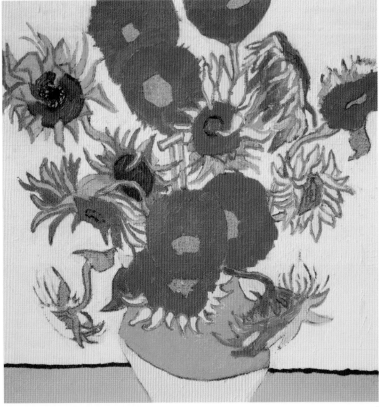

9.

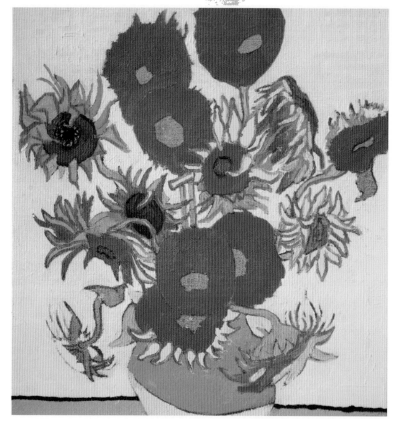

10. and 11.

10. Using ½ pea Leaf Green and flat brush no. 1, add another layer of green paint to the areas painted in step 9. If you find it difficult to paint the tight spaces, switch to detail round brush no. 1 for those areas.

11. Using ½ pea Yellow Green and detail round brush no. 1, add another layer of green to the areas painted in steps 9 and 10. The detail round brush allows you to add more texture to this area. On the bottom-right flower, also paint the small, unpainted triangular leaves with Yellow Green.

12. Using leftover Cadmium Green and detail round brush no. 1, outline the bottom-left leaf. Switch to leftover Emerald Green Nova and outline the stem and leaves of the bottom-right flower, as well as painting in its wispy leaves. Look at the reference photo for guidance.

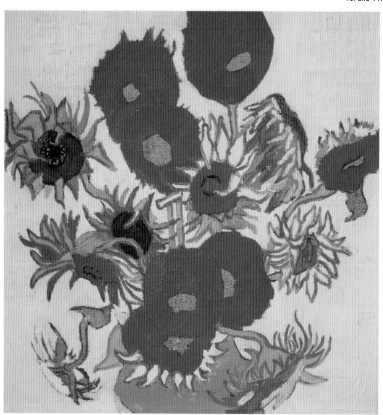

12.

13. Using ¼ pea Yellow Green and flat brush no. 1 (or detail round brush no. 1 for tight spaces), paint the stem and leaves of the flower in the lower-left corner. Look at the reference photo for guidance.

14. Using ¼ pea Greenish Yellow and detail round brush no. 1, go back over the area painted in step 13 to paint the leaf's shadows to add depth to the stem and leaves. Look at the reference photo for guidance.

15. Using ¼ pea Cadmium Green and detail round brush no. 1, add the line details and outlines to the bottom-left flower. Look at the reference photo for guidance.

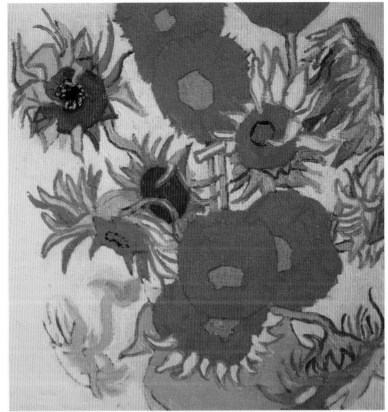

13. and 14.

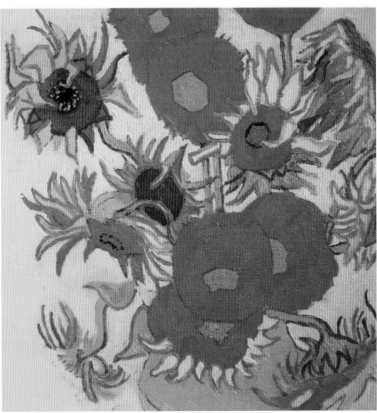

15.

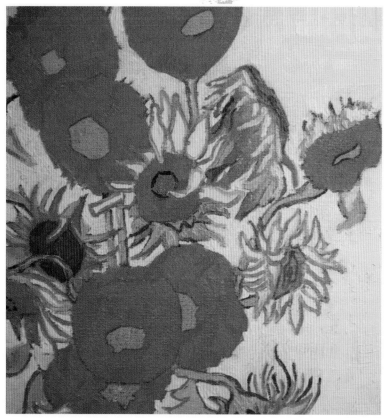

16. and 17.

16. Focus on the flower that is farthest to the right. Using ¼ pea Yellow Green and flat brush no. 1, paint the flower's bottom leaf.

17. Use any remaining Cadmium Yellow Lemon and flat brush no. 1 to add a highlight to the upper part of the leaf you painted in the previous step.

18. Use any leftover Cadmium Green and detail round brush no. 1 to outline the leaf and add line detail. Look at the reference photo for guidance.

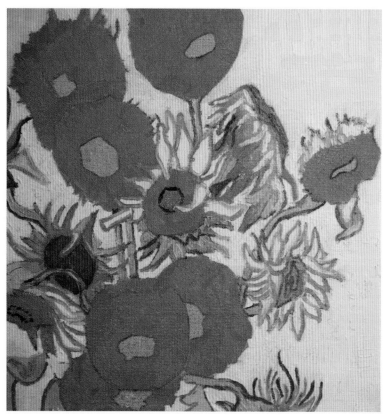

18.

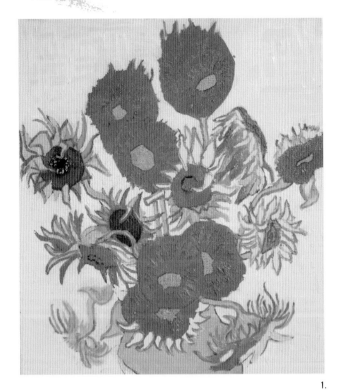

1.

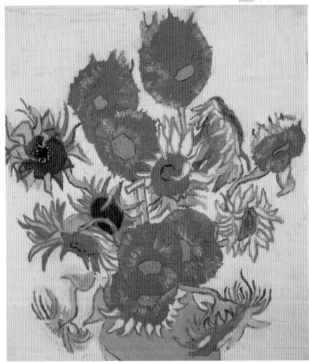

2.

PAINTING THE FLOWERS' OUTER CENTERS

1. Now focus on the three flowers at the top of the painting, the flower farthest to the right, and the three flowers at the bottom center. Using 1 quarter Yellow Ochre and round brush no. 1, add texture to the outer centers of these flowers. Make thick layers of 12 to 18 dabs of this color per flower.

2. Using 2 peas Cadmium Yellow Light Hue and round brush no. 1, repeat the same technique from step 1 on these flowers. Each flower requires a different number of dabs, so look at your reference photo for guidance. Wipe your brush every 3 dabs so that the colors do not become completely contaminated. Some blending is okay and creates a painterly effect, but too much blending can create unattractive flowers.

Forgery Tip

For this section, load the paintbrush with lots of paint and thickly dab it onto the canvas so that the brush is horizontal, or parallel, to the canvas. Avoid pushing the brush up and down while it is vertical, or perpendicular, to the canvas. By keeping the brush parallel to the canvas, you will use the brush's actual shape to do the painting, rather than the shape of the tip.

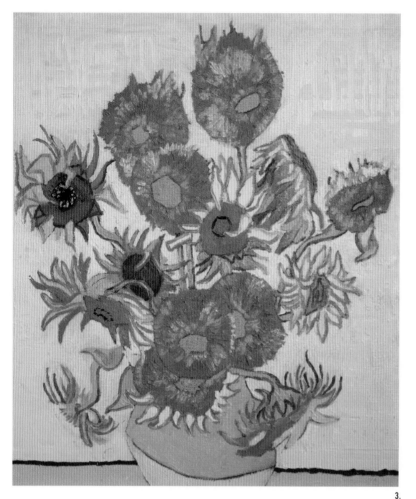

3.

3. Using 2 peas Cadmium Yellow Lemon and round brush no. 1, repeat the same technique from steps 1 and 2 on these flowers. Again, each flower requires a different number of dabs, so look at your reference photo for guidance. Wipe your brush every 3 dabs so that the colors do not become completely contaminated.

4. Using ½ pea Terra Rosa and round brush no. 1, repeat the same technique from steps 1 through 3 on these flowers. Each flower requires a different number of dabs, so look at your reference photo for guidance. Wipe your brush every three dabs so that the colors do not become completely contaminated.

5. Using 2 peas Yellow Ochre and round brush no. 1, add one final layer of this color to balance and fluff the flowers. Each flower requires a different number of dabs, so look at your reference photo for guidance. Wipe your brush every three dabs so that the colors do not become completely contaminated.

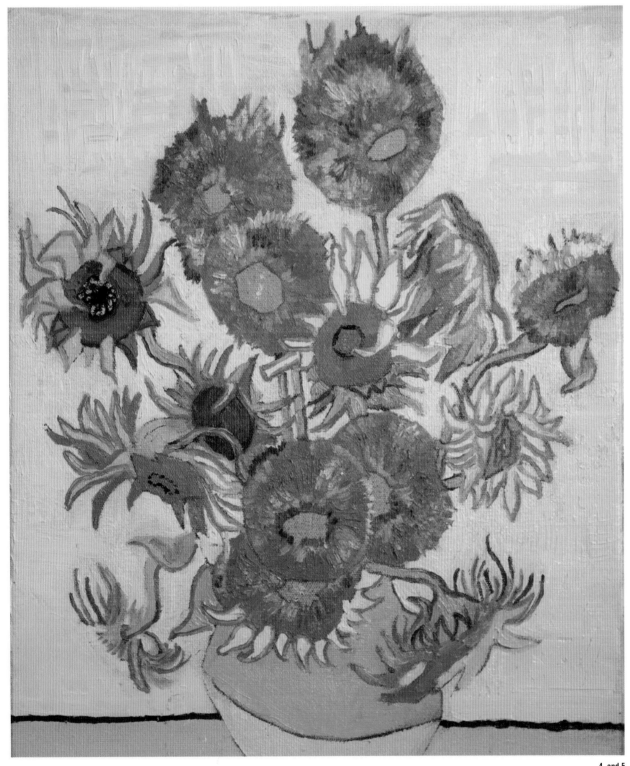

4. and 5.

PAINTING THE FLOWERS' CENTERS

1. Using 1 quarter Yellow Green and flat brush no. 1, paint thick strokes in the cores of the top three flowers, the farthest right flower, and the three bottom-center flowers.

2. Using 2 peas Leaf Green and detail round brush no. 1, swirl paint into the centers of the flowers you painted in step 1—this adds texture, shadow, and depth to the flowers. Wipe your brush every three strokes so that the colors do not become completely contaminated. Some blending is okay and creates a painterly effect, but too much blending can create unattractive flowers.

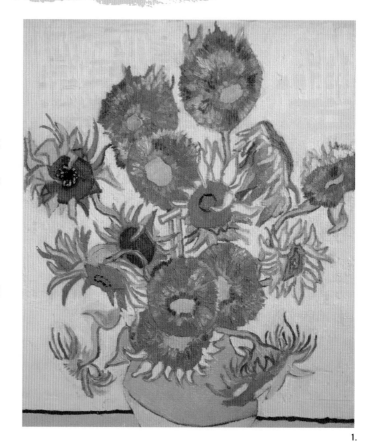

1.

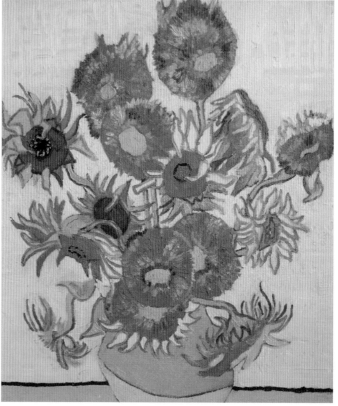

2.

1.

PAINTING THE FLOWER WITH THE BLUE CENTER

1. Using ½ pea Titanium White and round brush no. 1, paint a ring around the flower's outer center. Use a lot of paint to make this layer thick. Next, use ¼ pea Cadmium Yellow and round brush no. 1 to paint another ring, just inside the white ring. Again, use a lot of paint to make a thick layer. Finally, use any leftover Burnt Umber and round brush no. 1 to fill in the very center area.

2. Using leftover Terra Rosa and detail round brush no. 1, swirl the paint into the ring of Cadmium Yellow paint. Next, use ½ pea Cobalt Blue and detail round brush no. 1 to paint blue into the Titanium White ring. Allow the colors to mix directly on the canvas until you achieve the desired shade—you don't want the color to be uniform throughout this ring. If you look closely at the reference photo, you can see that the Cobalt Blue is stronger on the left side of the ring.

2.

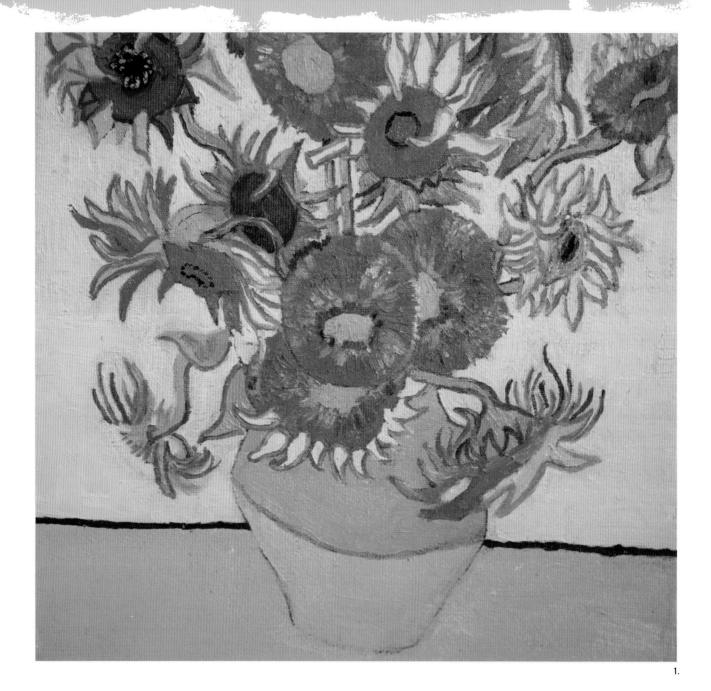

1.

PAINTING THE FINISHING TOUCHES

1. Mix leftover Cobalt Blue with 1 pea Titanium White. Use detail round brush no. 1 and the resulting light blue color to paint the horizontal line on the vase separating the top and bottom colors.

2. Use any remaining paint on your palette to add more of Van Gogh's signature texture. You can also continue your painting around the edges of the canvas or paint them a solid color, especially if you're not planning on framing the painting. The painting will take three days to fully dry. Store it flat on a table until it is dry.

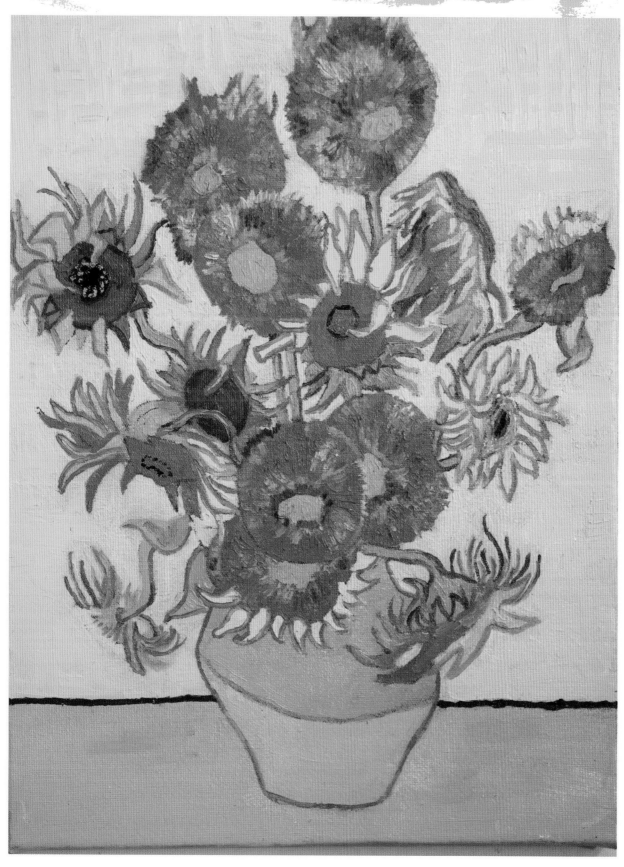

A completed forgery of Van Gogh's *Sunflowers.*

Exterior of a Restaurant in Asnières

PARIS, FRANCE, 1887

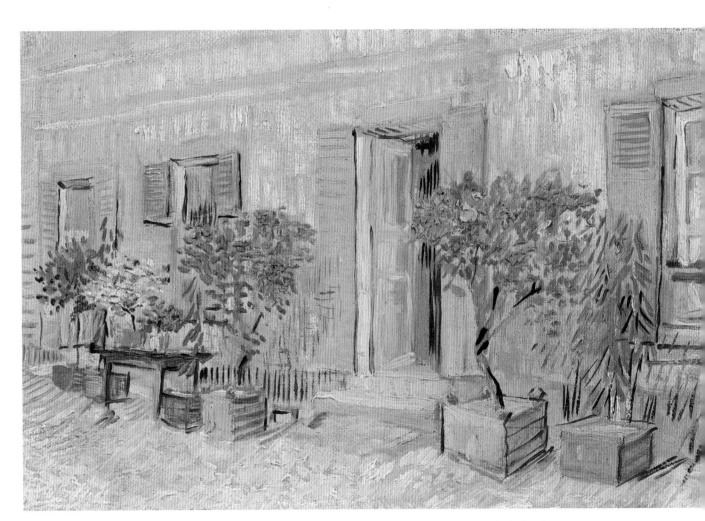

Exterior of a Restaurant in Asnières, Van Gogh Museum, Amsterdam (Vincent van Gogh Foundation).

> "And when I painted . . . in Asniéres this summer I saw more color in it than before."

—Vincent van Gogh in a letter to his brother Theo van Gogh, October 1887

Impressionism, a style of painting that originated in France in the 1860s–1880s, depicted the visual impression of a moment with a focus on light and color. While he can't be classified as an Impressionist painter, Vincent van Gogh was certainly influenced by that movement, which can be seen in some paintings. When Van Gogh lived in Paris with his art dealer brother Theo, he was introduced to many of his brother's Impressionist clients, including Degas, Monet, Pissarro, Renoir, and Seurat. It was here he also met Paul Gauguin, who joined him the following year to paint in Arles, in the south of France.

Van Gogh often went to Asnières, a suburb in the north of Paris, to paint typical Impressionist subjects in the open air, such as street scenes, bridges, and restaurants. He would regularly meet and paint with Paul Signac, who wrote, "I would encounter [Van Gogh] at Asnières and Saint-Ouen. We painted together on the riverbanks, we lunched at roadside cafes and we returned by foot to Paris via the Avenues of Saint-Ouen and Clichy. Van Gogh, wearing the blue overalls of a zinc worker, would have little dots of color painted on his shirtsleeves. Striking quite close to me, he would be yelling, gesticulating and brandishing a large size-thirty, freshly painted canvas; in this fashion he would manage to polychrome both himself and the passers-by."

For this simple composition of the exterior of a restaurant, Van Gogh used warm summer colors of yellow, red, and green and short brushstrokes to evoke a strong feeling of a sunny summer day. Instead of working in the somber colors of his earlier work in Holland, Van Gogh embraced the Impressionists' use of color and light.

In tribute to the artist, there's now a restaurant called "Le Van Gogh" in Asnières on the banks of the River Seine.

Exterior of a Restaurant in Asnières

MATERIALS

- 16 × 12-inch (40 × 30 cm) canvas (you can work on a flat surface or an easel)
- Holbein Heavy Body Artist Acrylic in Raw Sienna
- Palette knife
- Sponge or paper towel
- Ruler or T-square
- No. 2 graphite pencil
- Prismacolor marker in Light Pink
- Pink Pearl Eraser
- Palette or plastic plate
- Flat brushes (nos. 1, 2, 4)
- Round brush (no. 1)
- Detail round brush (no. 1)

OIL COLORS

- Lemon Yellow
- Leaf Green
- Cadmium Yellow
- Titanium White
- Ice Green
- Phthalo Blue
- Ivory Black
- Indigo
- Greenish Yellow
- Phthalo Green
- Brilliant Pink
- Yellow Ochre
- Cadmium Green

PRIMING AND PREPARING THE CANVAS

1. to 3. Please refer to page 14.

4. Once your grid is prepared, it is essential to sketch an accurate drawing to use as your guide once you start painting. Use the Restaurant template on page 169 as your guide. You can either free-form sketch or trace the template. See "Drawing on Your Canvas" on page 9 for more instruction on how to use the template and your grid to make the drawing.

5. After completing the drawing, trace over the lines of the drawing (not the grid lines) with a Prismacolor marker. Now use your eraser to remove all the graphite pencil markings—both the drawing and the grid lines. Graphite will discolor the paint, so it is important to remove it. Don't worry about the marker—the thick lines of your Van Gogh painting will ensure that the marker is covered up.

NOTE: Though these images show a white canvas, your canvas will have been primed with the Raw Sienna acrylic paint.

4.

5.

1.

2. and 3.

PAINTING THE EXTERIOR WALL

1. On your palette using your palette knife, mix together 1 quarter Lemon Yellow, 1 quarter Leaf Green, and ¼ pea Cadmium Yellow. To mix the paint using your palette knife, scoop, press, spread, and fold the paint together, until it is thoroughly and evenly mixed. Using flat brush no. 4, apply paint to the exterior wall of the restaurant in up-and-down brushstrokes, carefully painting around the drawing lines.

2. With 1 quarter Titanium White and flat brush no. 1, fill in the wall's trim lines in the upper canvas.

3. With leftover Titanium White, add Van Gogh's signature texture to the exterior wall of the restaurant using flat brush no. 1. Pull your brush in a straight downward motion to keep your lines straight. Allow some of the paint to mix in with the yellow on some of the strokes, but on other strokes, use a gentle touch so that the white stands out on its own. At this point, also paint the horizontal line above the door. Look at the reference photo for guidance.

4. Using flat brush no. 1, add dabs of leftover yellow wall mixture (see step 1 in this section, page 102) and Titanium White inside of the trees framing the doorway (about 12 dabs per tree, 6 dabs of each color), as well as to the taller plant (about 8 dabs, 4 dabs of each color) on the table on the left side of the canvas. These dabs will represent the wall peeking through the leaves of the trees and plant.

4.

PAINTING THE PLANTERS AND SHUTTERS

1. Mix 1 quarter Ice Green, 1 dot Phthalo Blue, 1 pea Titanium White, and 2 peas leftover yellow wall mixture (see step 1, "Painting the Exterior Wall of the Restaurant," page 102). Look closely at your reference photo and paint in the parts of the planters pictured using flat brush no. 1. Next, fill in all of the shutters, leaving the drawn slat guidelines visible. Use a lot of paint to add texture and thickness. Also paint in the upper window frame of the far-left window and the lower, closed shutters on the window second from the left.

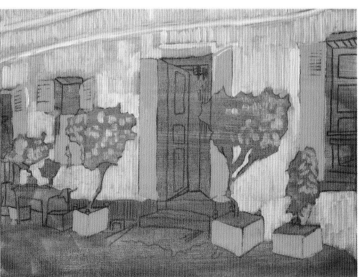

1. and 2.

2. With the same paint mixture as in the previous step, use round brush no. 1 to add dabs of paint to the trees in places where they overlap the shutters, except for the tree overlapping the shutter to the right of the door.

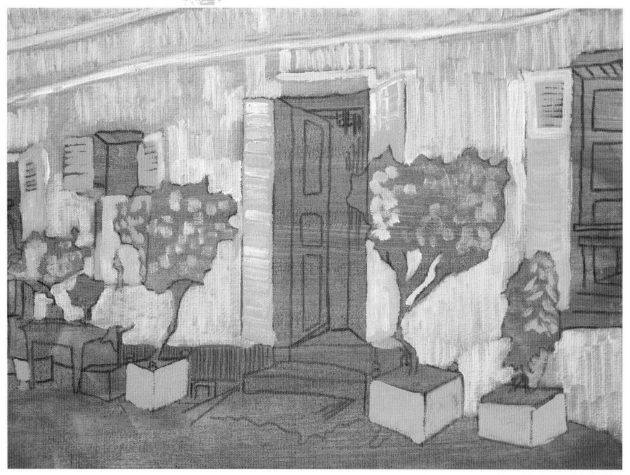

3. through 5.

3. For the next three steps, you're going to add white details to the shutters using ½ quarter Titanium White. Starting with detail round brush no. 1, add the grid-like details to the top of the shutter on the right side of the doorway. Switch to flat brush no. 1 to paint the white horizontal slat detail (about 20 slats) on the shutter that is to the left of the doorway, then gently brush in white to the lower half of the shutter that is to the right of the doorway—use up-and-down strokes to lighten and add texture.

4. Outline the top portion of the far-right shutter. Beneath the light rectangle you just painted, add in horizontal slat details (about 11 slats). Next, outline the top and right side of the right shutter on the window second from the left. In the bottom half of this window, sweep in Titanium White in up-and-down strokes to brighten the closed shutters. Use the same technique to add bright texture to the shutter on the far-left window.

5. Go ahead and add more dabs of color, using your dirty brush, to the trees overlapping the far-left shutter and the shutter to the right of the doorway—it is a great way to blot in Titanium White and your shutter paint mixture in one step. Look at your reference photo for guidance.

PAINTING THE WINDOW AND DOOR TRIM

1. Using flat brush no. 1 and leftover Titanium White, paint the outer trim—bottom and left side (doorjamb) only—of the door. Next, paint the frames of the door and the window on the far right. Moving to the left side of the painting, paint the top and left frame of the window second to the left, and add the center horizontal detail and lower vertical lines (3 lines) to the far-left window.

2. Using flat brush no. 1, add some leftover yellow wall mixture (see step 1, "Painting the Exterior Wall of the Restaurant," page 102) inside the doorway. Add the same paint mixture to the lower step outside the doorway, then wipe your brush clean and sweep Titanium White over the front and top of the yellow stair to lighten it. Allow the colors to mix on your canvas for a painterly effect; don't let the color flatten.

3. Add ½ pea leftover yellow wall mixture (see step 1, "Painting the Exterior Wall of the Restaurant," page 102) to the remaining Titanium White. (If you used all of the white, mix 2 peas Titanium White with ½ pea wall mixture.) With flat brush no. 1, you're going to define the windowpanes. First, paint the left half of the panes in the door frame. Next, completely fill the panes of the far-right window. Moving to the left side of the painting, fill in about three-quarters of the pane in the second-to-left window and half of its upper pane, narrowing your stroke to about a quarter of the lower pane of the far-left window. Continuing with this color and brush, paint the trim of the far-right window.

1. and 2.

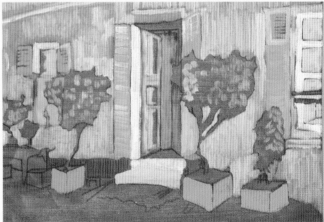

3.

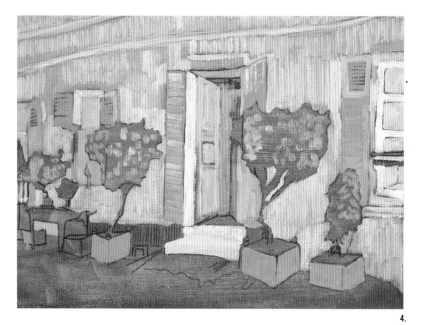

4.

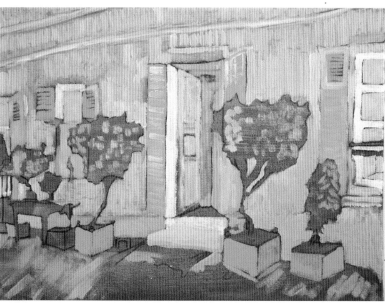

5.

4. Mix 1 pea leftover shutter/planter mixture (see step 1, "Painting the Planters and Shutters," page 103), 1 quarter Titanium White, and 1 dot Ivory Black. Using flat brush no. 1, add more definition to the windowpanes, giving them a glass-like finish. Apply this color to the unpainted areas of the windowpanes of the door and the two windows on the left. Following the reference photo, lightly apply it to the panes of the far-right window. Also paint the trim around the door as well as part of the exterior wall underneath the table on the left side of the canvas.

5. Mix in another dot of Ivory Black to the remaining paint mixture from step 4 for a grayish color. Using flat brush no. 1, continue painting the back wall, starting from below the desk to the doorway steps. Add a layer of this mixture to the open door and top trim, then outline the lower step and the two planters on the right. Next, using diagonal strokes, shade in front of and around the planters and steps. Finally, move to the right-hand side of the restaurant wall and use short vertical strokes to create texture on the bottom 2 inches (5 cm) of the wall. Look at your reference photo for guidance.

6. Continuing with this gray mixture and flat brush no. 1, shade the doorjamb on the left side of the door and finish the trim around the door's window-panes. Also paint the interior floor of the doorway (the trapezoid shape).

7. For the next four steps, you're going to be painting in the blue details (look at your reference photo) using detail round brush no. 1. Mix 1 pea Phthalo Blue with 1 pea Indigo. Outline the windows, windowpanes, door, and shutters, following the reference photo. Using this same brush, squiggle some of the blue mixture onto the bottom windowpane of the far-right window—this will create depth and add perspective to the interior of the restaurant.

8. Add cross-hatching detail to the restaurant wall to the bottom left of the door. Continue the cross-hatching onto the left shutter. Use a pattern of short and long vertical lines to add details to the inner-right doorway. Continue adding these lines to the top of the door frame; switch to diagonal lines to add the inside depth of your doorway.

9. Add evenly spaced vertical lines (about 32 lines, ⅛ inch [2–3 mm] apart) to the gray strip of wall in between the desk and the doorway steps.

10. Outline the two drawn lines on the ground to the left of the steps, as well as the upside-down U-shaped object to the left of the lines—this will add perspective to the ground of your painting. Finally, add what looks like a cross below the far-left window.

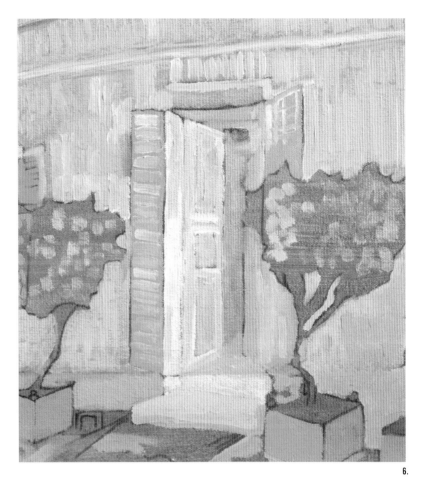

6.

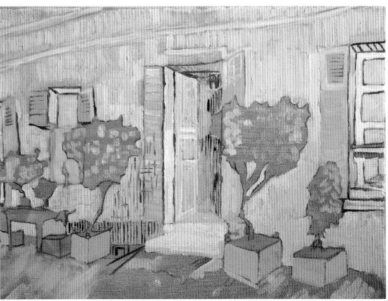

7. through 10.

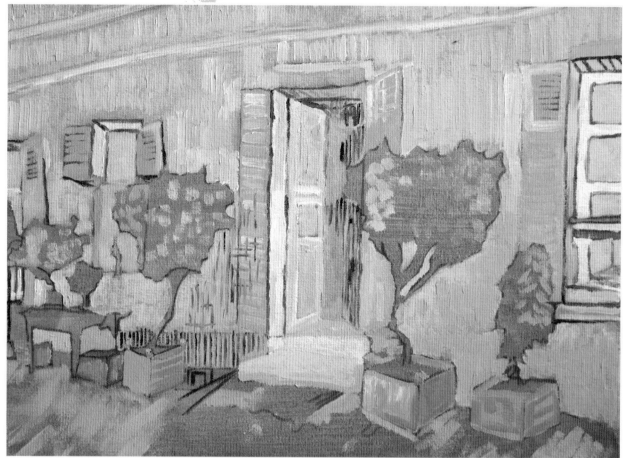

1. through 3.

ADDING DETAILS TO THE PLANTERS

1. Mix 1 pea Greenish Yellow with 1 pea Phthalo Green. Using flat brush no. 1, paint the smaller, empty planter to the right of the table. Reserve leftover paint mixture for painting the table later.

2. Mix 1 dot each of Phthalo Blue and Phthalo Green with all the leftover shutter/planter mixture (see step 1, "Painting the Planters and Shutters," page 103). With flat brush no. 1, paint the two planters on the far left. Next, use the same color and brush to shade the three large planters on the right. Look closely at your reference photo for guidance.

3. Using ½ pea Titanium White and flat brush no. 1, add highlights to all of the planters.

4. With detail round brush no. 1 and leftover Phthalo Blue/Indigo mixture (see step 7, "Painting the Window and Door Trim," page 107), add the final outlines and details to all of the planters. (Use your reference photo to see which parts to outline and where to add lines to define the wooden slats.) Paint 2 lines on the ground to the right of the planter second from the right. While you're at it, also paint the clusters of diagonal vertical lines on the restaurant wall around the far-right planter (4 lines to the left of the planter, 3 above the right side of the planter, and 7 on the wall to the right).

5. Add 1 pea Titanium White to your remaining Phthalo Blue/Indigo mixture, then use detail round brush no. 1 to add light blue details to the shutters. Paint the visible slat lines on the upper shutters of the far-right window (8 lines), the second-to-left window (5 lines per shutter), and the far-left window (7 lines). Also, slightly outline the top-right side of the shutter to the right of the doorway.

6. Using leftover dark gray mixture (see step 5, "Painting the Window and Door Trim," page 106) and flat brush no. 2, fill in the lower restaurant wall below the far-left window. Use ½ pea Titanium White and flat brush no. 1 to fill in the tops of the two planters to the right of the door and the two planters to the left of the door.

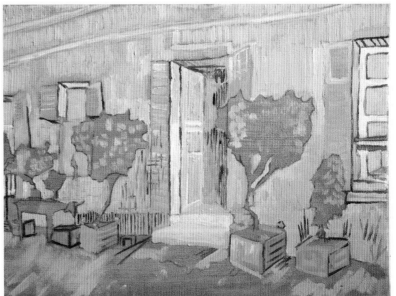

4. and 5.

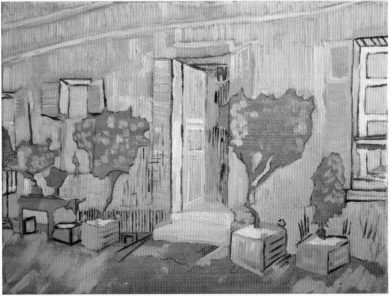

6.

1.

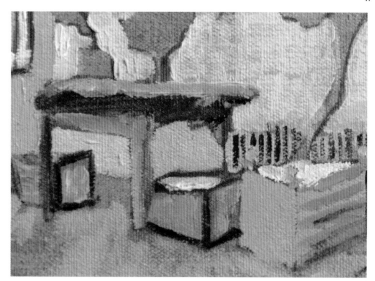

2.

PAINTING THE TABLE

1. Use leftover Greenish Yellow/Phthalo Green mixture (see step 1, "Adding Details to the Planters," page 108) and flat brush no. 1 to fill in the entire tabletop, the front, the left front leg, and the right side of the right front leg.

2. With ⅓ pea leftover shutter/planter mixture (see step 1, "Painting the Planters and Shutters," page 103) and flat brush no. 1, add a lighter layer of paint to the tabletop, the front, and the right front leg.

3. Mix together ¼ pea each of Indigo and Phthalo Blue. Using detail round brush no. 1, add the dark blue lining details to your table, using the reference photo for guidance.

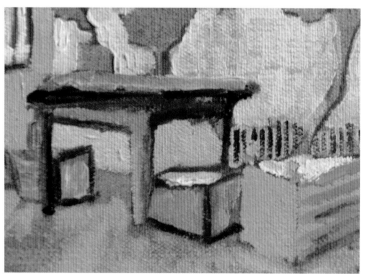

3.

PAINTING THE GROUND

Note: The painting in this section involves a layering process to get the desired effect, so look closely at the reference photos for guidance.

1. Using leftover dark gray mixture (see step 5, "Painting the Window and Door Trim," page 106) and flat brush no. 1, add more short, quick diagonal strokes to the ground.

2. Put 1 quarter Titanium White on your palette; you won't use all of it in this step. Using flat brush no. 1, add more short, quick diagonal strokes to the ground around and above the gray paint.

3. Using leftover yellow wall mixture (see step 1, "Painting the Exterior Wall of the Restaurant," page 102) and flat brush no. 1, continue adding short, quick diagonal strokes to the ground. Remember, this is a layering process, so overlapping the colors is encouraged! Also use flat brush no. 1 and this color to fill in the rectangular area below the step of the restaurant's entrance.

1.

2.

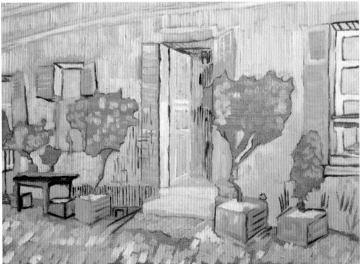

3.

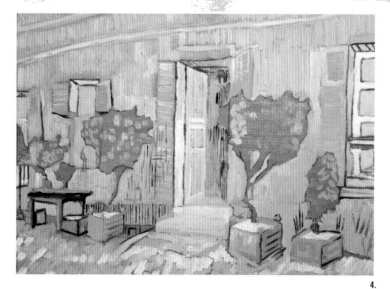

4.

4. Using the Titanium White paint from step 2 in this section and flat brush no. 1, layer more white paint onto the ground. Also swirl the white into the yellow green below the step that you painted in step 3. This creates a nice painterly effect and adds texture to the area.

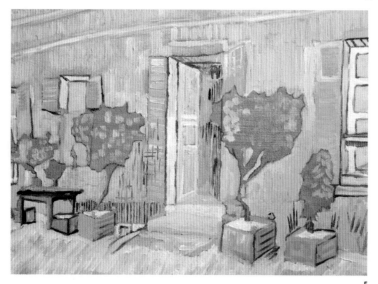

5.

5. Using leftover Titanium White and flat brush no. 1, layer in even more white paint. Allow it to slightly mix with the colors beneath as you layer it in, but periodically wipe your brush with a paper towel so that the colors don't blend together completely. The ground should be completely filled at this point. Also use this paint to fill in the drain to the left of the steps.

6.

6. Using leftover dark gray mixture (see step 5, "Painting the Window and Door Trim," page 106) and flat brush no. 1, add gray details to the front of the top, white step. Paint 6 evenly spaced vertical lines that are the width of the brush.

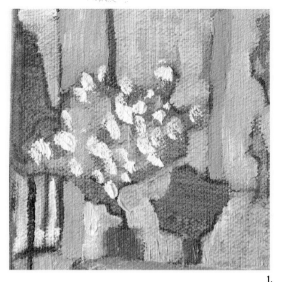

PAINTING THE TREES AND PLANTS

1. Put ½ pea Titanium White on your palette. Use round brush no. 1 to stipple the paint onto the tree on the table. Look at the reference photo for guidance.

2. Put ½ pea Brilliant Pink on your palette. Using round brush no. 1, stipple a layer of pink dots on top of the white dots on the same tree. A slight mixing of the two colors adds a painterly effect, but continue to wipe your brush every three or four applications to keep them from blending completely.

3. Alternate between stippling Titanium White and Brilliant Pink onto the same plant. When you are happy with the result, stipple a few dots of Brilliant Pink into the plant on the table, just to the right.

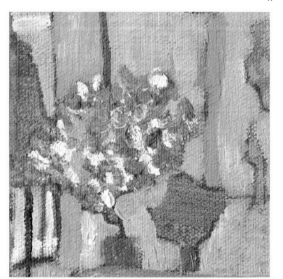

Forgery Tip

To create the flower buds and leaves of the trees, you will use a stippling technique where you layer dots. Wipe your brush after every third or fourth application of paint so that the colors do not completely mix together.

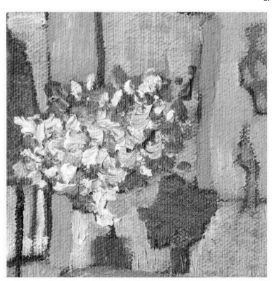

4. Put 1 pea Yellow Ochre on your palette. Using detail round brush no. 1, paint the two pots holding the plants on the desk. Also paint the two horizontal brown bars on the far-right window.

5. Mix 1 pea each of Leaf Green and Greenish Yellow. Using round brush no. 1, stipple the mixture into the trees flanking the entrance to the restaurant, into the plant on the right side of the table, and into the tree in front of the far-left window. Like the flowers, this will be a process of layering, so complete coverage isn't necessary now.

4. and 5.

6. Use 1 pea Cadmium Green and round brush no. 1 to stipple more leaves onto the trees flanking the entrance. You will also use the Cadmium Green for the three evergreen trees—the one behind the flowering bush, the one on the table, and the one in front of the far-right window. For these trees, use round brush no. 1 and diagonally angle the bristles from left to right. Use an up-and-down stippling motion. Look at the reference photo for guidance.

7. Use 1 pea Yellow Ochre and round brush no. 1 to stipple more leaves onto the two trees flanking the entrance and the small plant on the table.

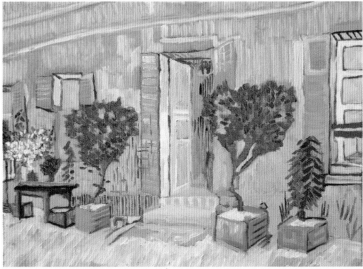

6. and 7.

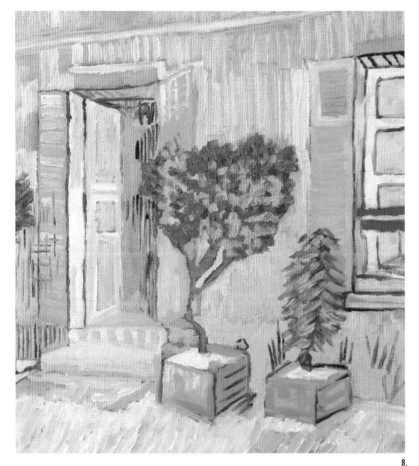

8.

8. Use ⅓ pea leftover yellow wall mixture (see step 1, "Painting the Exterior Wall of the Restaurant," page 102), ⅓ pea shutter/planter mixture (see step 1, "Painting the Planters and Shutters," page 103), and ⅓ pea Cadmium Green and round brush no. 1 with the stylized angled stipples to add layers of dots to the evergreen plant in front of the far-right window. Continue until you get the desired effect. Look at the reference photo for guidance.

9. Continue to use round brush no. 1 and stipple layers of ⅓ pea shutter/planter mixture (see step 1, "Painting the Planters and Shutters," page 103), ⅓ pea yellow wall mixture (see step 1, "Painting the Exterior Wall of the Restaurant," page 102), ⅓ pea yellow green mixture (see step 5 in this section), ⅓ pea Cadmium Green, ⅓ pea Leaf Green, and ⅓ pea Yellow Ochre onto the trees flanking the entrance and the small plant on the table. Wipe your brush every few applications so that the colors do not completely blend.

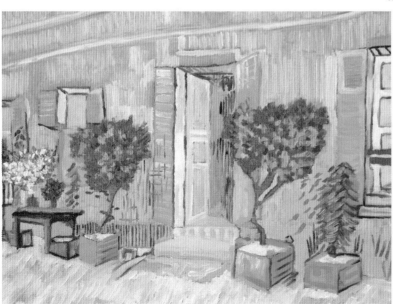

9.

1. and 2.

3.

PAINTING THE FINISHING TOUCHES

1. Use the remaining paint on your palette and flat brush no. 1 to begin adding the final details to the painting. Van Gogh speckled the wall of the restaurant with hints of vegetation, so use the leftover paint from the leaves to add these hints. Alternate between the dot stipple and the stylized diagonal stipple. Also paint some strokes of leftover shutter/planter mixture (see step 1, "Painting the Planters and Shutters," page 103) beneath the far-right window. Paint the trunks of the trees flanking the door with leftover dark gray mixture (see step 5, "Painting the Window and Door Trim," page 106). Stipple some of the leftover Cadmium Green and yellow green leaf mixture on top of the trunk of the tree to the left of the door. Look at the reference photo for guidance.

2. Using leftover Titanium White paint and round brush no. 1, layer white on top of the trunk of the evergreen on the right.

3. Using ⅓ pea or leftover Phthalo Blue/Indigo mixture (see step 7, "Painting the Window and Door Trim," page 107) and detail round brush no. 1, add details to the trunks of the trees flanking the doorway and the tree on the table. Add some diagonal blue lines under the desk to show shadows and floor lines. Finally, add dark details to the evergreen tree on the far right. Look at the reference photo for guidance.

4. Use any remaining paint on your palette to add more of Van Gogh's signature texture. You can also continue your painting around the edges of the canvas or paint them a solid color, especially if you're not planning on framing the painting. The painting will take three days to fully dry. Store it flat on a table until it is dry.

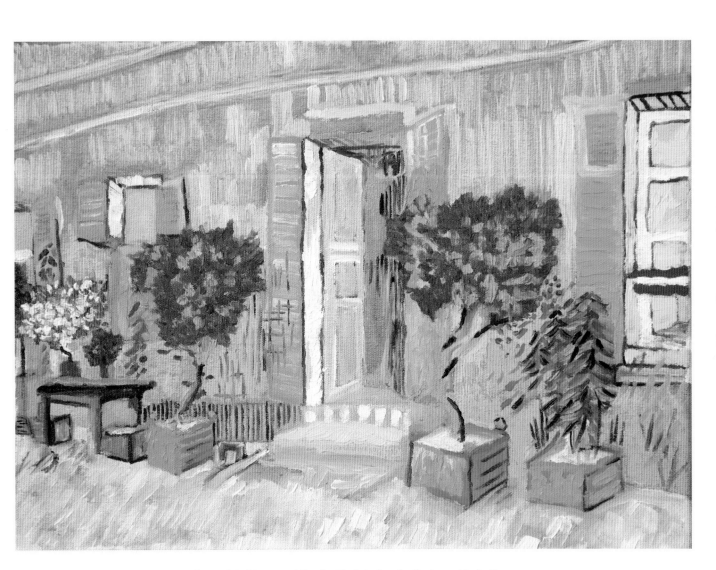

A completed forgery of Van Gogh's *Exterior of a Restaurant in Asnières*.

The Bedroom

ARLES, FRANCE, OCTOBER 1888

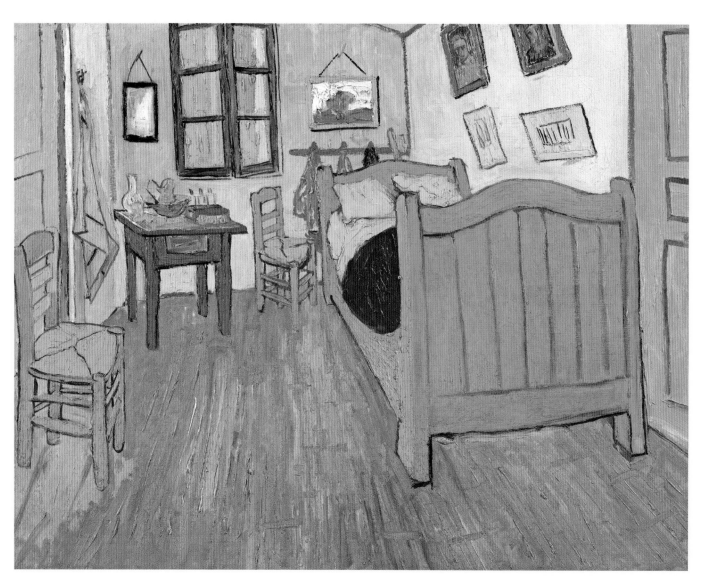

The Bedroom, Van Gogh Museum, Amsterdam (Vincent van Gogh Foundation).

"I had a new idea in mind This time it's simply my bedroom, but the color has to do the job here, and through its being simplified by giving a grander style to things, to be suggestive here of rest or of sleep in general. In short, looking at the painting should rest the mind, or rather, the imagination."

—Vincent van Gogh in a letter to his brother Theo van Gogh, October 1888

In 1888, Van Gogh moved south to Arles in Provence in search of more vibrant, deeper colors and hoping to found an artists' community. Unfortunately, this community, his "Studio of the South," didn't come to fruition. He did manage to persuade his artist friend Paul Gauguin to join him and they did collaborate briefly. However, working together was tumultuous to say the least and Gauguin left after Van Gogh's infamous ear mutilation episode. Van Gogh's doctor diagnosed a combination of epilepsy and mental illness, which unfortunately was never cured.

This painting depicts Van Gogh's bedroom at 2 Place Lamartine, Arles, which was one of four rooms he rented in what was known as the "Yellow House," also the subject of another of his well-known paintings. Van Gogh's use of bold and vibrant colors demonstrates his move away from the Impressionists' use of pastel colors.

Although he wrote to his sister Willemien in 1889 that she would "probably find the interior the ugliest, an empty bedroom with a wooden bed and two chairs," he "wanted to arrive at an effect of simplicity. . . . To make simplicity with bright colors isn't easy though, and I find that it can be useful to show that one can be simple with something other than grey, white, black and brown."

Van Gogh's painting of his bedroom in the Yellow House shows simple, pine furniture and his own paintings on the walls. The portraits by Van Gogh over the bed are of the Belgian painter Eugène Boch and the soldier Paul-Eugène Milliet. The simple furnishings and cheerful colors were intended to portray a restful scene, for both Van Gogh and the viewer.

Although Van Gogh clearly was striving to use vibrant colors, recent research shows that the painting has suffered significant discoloration over the years. The contrast in the work in 1888 wouldn't have been so great. For instance, the walls and doors were originally purple rather than blue.

Van Gogh's painting of his bedroom was one of his favorites, as he says in his letter to Theo: "When I saw my canvases again after my illness, what seemed to me the best was the bedroom."

The Bedroom

MATERIALS

- 16 × 12-inch (40 × 30 cm) canvas (you can work on a flat surface or an easel)
- Holbein Heavy Body Artist Acrylic in Raw Sienna
- Palette knife
- Sponge or paper towel
- Ruler or T-square
- No. 2 graphite pencil
- Prismacolor marker in Light Pink
- Pink Pearl Eraser
- Palette or plastic plate
- Flat brushes (nos. 1, 2)
- Detail round brush (no. 1)

OIL COLORS

Titanium White
- Cobalt Blue
- Phthalo Blue
- Cerulean Blue
- Cadmium Yellow Hue
- Cadmium Yellow
- Cadmium Yellow Light Hue
- Naples Yellow
- Terra Rosa
- Cadmium Red
- Yellow Ochre
- Quinacridone Gold
- Cadmium Orange
- Phthalo Green
- Cadmium Green
- Ivory Black
- Lemon Yellow
- Cobalt Turquoise
- Jaune Brillant
- Burnt Sienna

PRIMING AND PREPARING THE CANVAS

1. to 3. Please refer to page 14.

4. Once your grid is prepared, it is essential to sketch an accurate drawing to use as your guide once you start painting. Use the Bedroom template on page 170 as your guide. You can either free-form sketch or trace the template. See "Drawing on Your Canvas" on page 9 for more instruction on how to use the template and your grid to make the drawing.

5. After completing the drawing, trace over the lines of the drawing (not the grid lines) with a Prismacolor marker. Now use your eraser to remove all the graphite pencil markings—both the drawing and the grid lines. Graphite will discolor the paint, so it is important to remove it. Don't worry about the marker—the thick lines of your Van Gogh painting will ensure that the marker is covered up.

NOTE: Though these images show a white canvas, your canvas will have been primed with the Raw Sienna acrylic paint.

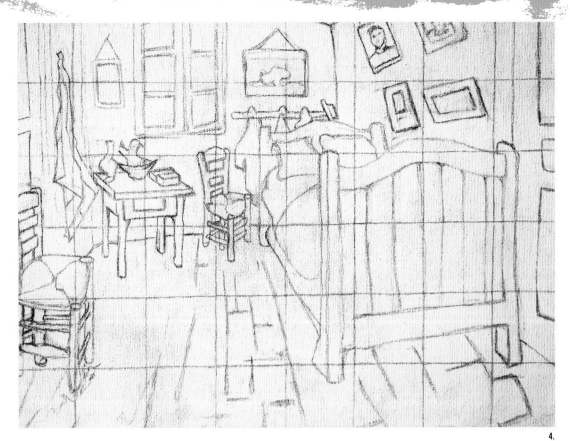

4.

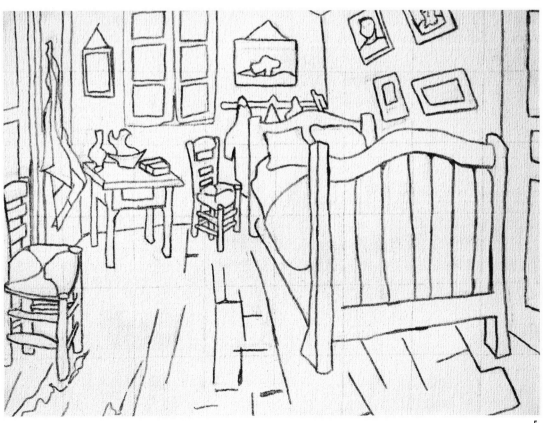

5.

PAINTING THE WALLS AND DOORS

1. To create the blue wall color, mix 1 pea Titanium White with 1 quarter Cobalt Blue on your palette with a palette knife. To mix the paint using your palette knife, scoop, press, spread, and fold the paint together, until it is thoroughly and evenly mixed. Using flat brush no. 1, paint the back wall with up-and-down strokes, painting up to the edges of the drawing. Also paint the upper-right corner of the ceiling. Continue painting the left-hand door in the same manner, being sure to paint within the outlined sections in order to leave drawn guidelines for adding door details later. Do not paint inside the legs of the chairs; that area will be filled in later.

2. Mix any leftover blue from step 1 with 1 dot each of Cobalt Blue and Phthalo Blue. Paint the right-hand door in the same way as you did the left-hand door, being sure to paint within the outlined sections in order to leave drawn guidelines for adding door details later.

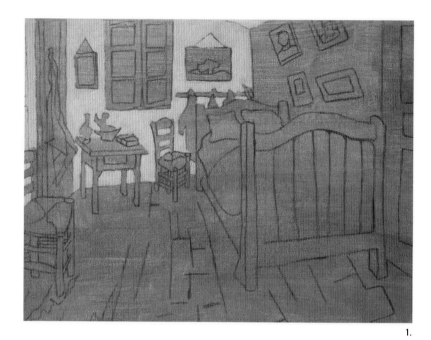

1.

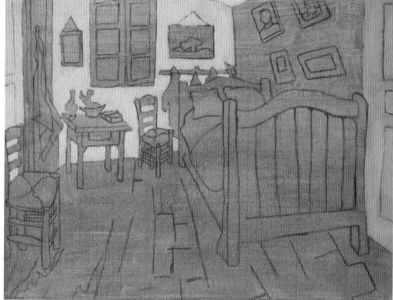

2.

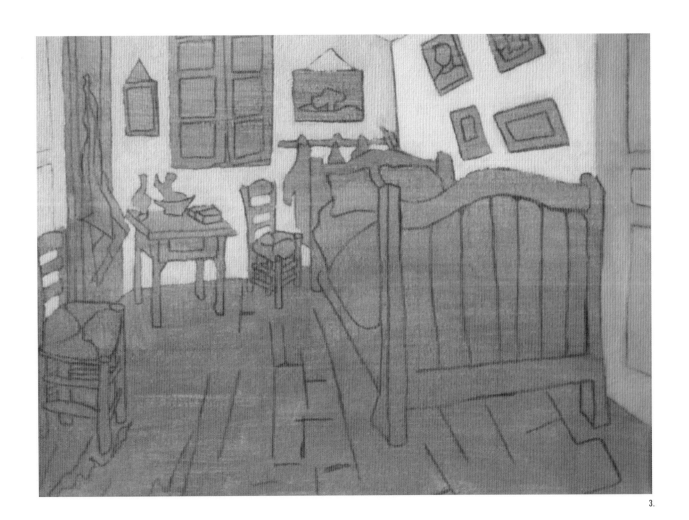

3.

3. Mix 1 pea of blue from step 2 with 1 quarter Titanium White. Using flat brush no. 2, paint the wall on the right side with up-and-down strokes, painting up to the edges of the drawing.

PAINTING THE DOORS AND WALL TRIM

1. Mix ½ pea door blue (step 2, Painting the Walls and Doors, page 122.) and 1 dot Phtalo Blue. Using flat brush no. 1, paint the line of trim directly to the right of the left-hand door. Using ½ pea Cobalt Blue and detail round brush no. 1, paint over the three drawn outlines of the wall and ceiling that connect the back and right walls. It's okay for this blue to interact with the existing wall blues, because it gives the look of Van Gogh's painterly style.

2. Going back to the left-hand door, use ½ pea Titanium White and flat brush no. 1 to paint the second line of trim to the right of the blue wall trim from the previous step.

3. To paint the details of both doors, mix together 1 pea each of Cobalt Blue, Cerulean Blue, and Phthalo Blue. Using a line brush, first paint over the drawn lines of the inside of the doors, then outline the trim lines to the right of the left-hand door. Continue painting the inner and outer details of the right-hand door, then finish by painting a vertical line between the back and left walls.

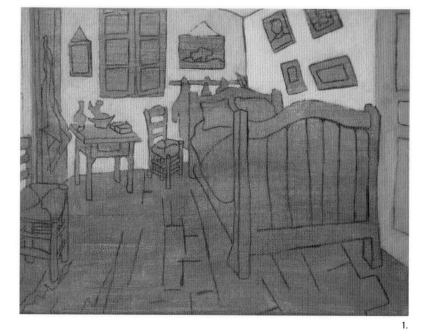

1.

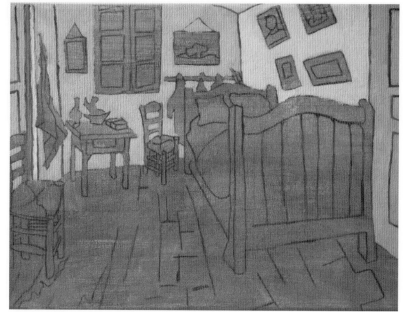

2. and 3.

PAINTING THE BED AND CHAIRS

1. Mix together 1 quarter each of Cadmium Yellow Hue and Cadmium Yellow. Using flat brush no. 1, paint the slats, the area below the slats, and the posts of the bed's footboard in an up-and-down motion, leaving the drawn lines visible. Paint the curved top of the footboard from side to side, staying with the bend of the lines. Move to the headboard and carefully paint the curved part and upper posts. Finally, paint the frame of the chair to the left of the bed, following its lines.

2. Mix together 1 pea each of Cadmium Yellow Light Hue and Naples Yellow. Using flat brush no. 1, paint the base of the bed and the left sides of the posts. Also paint the frame of the far-left chair, excluding its back slats.

3. To paint the bed's quilt, use ½ pea Terra Rosa with flat brush no. 1. Lay down the paint flat and thick. To create texture on the quilt, swirl in ¼ pea Cadmium Red with the already-painted Terra Rosa. You do not want the two colors to completely mix together because that will flatten the paint; use a swirling motion to achieve a random mixture of color.

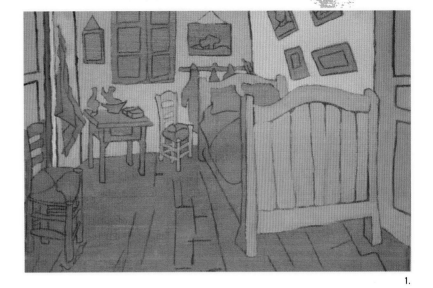

1.

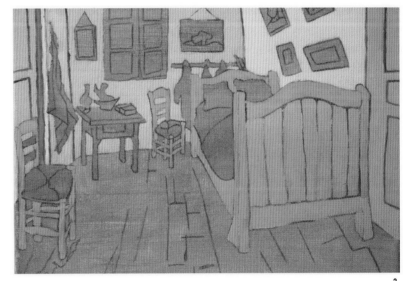

2.

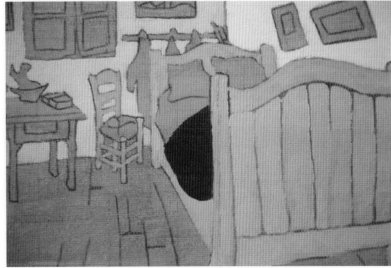

3.

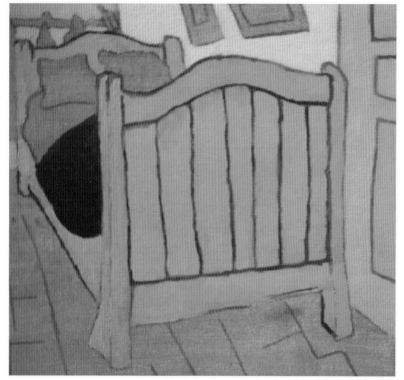

4. through 6.

4. To add detail to the bed frame, use ¼ pea Terra Rosa and detail round brush no. 1. Start with the left post of the headboard, following the upper curve of the frame and defining the right post. Move on to painting the footboard outline and the slat lines. Look at the reference photo for guidance.

5. Also use ⅓ pea Terra Rosa and detail round brush no. 1 to outline the base of the bed frame and the foot of the back-left leg.

6. Using ¼ pea Yellow Ochre, add "wood" detail to the tops of the left-side bedposts (corners).

7. Continuing with Terra Rosa and detail round brush no. 1, outline the chair to the left of the bed. Look at the reference photo closely for guidance.

7.

1.

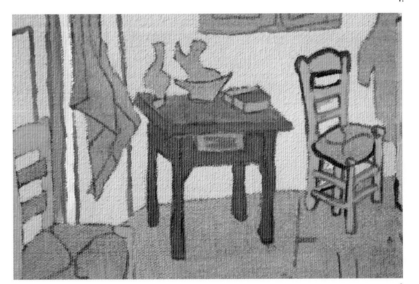

2.

PAINTING THE DESK AND COATRACK

1. With ½ pea Quinacridone Gold and flat brush no. 1, paint the entire desk, keeping the layer on the desktop very thin. Do not paint the desk drawer. Also paint the lower half of the book cover this color.

2. With ½ pea Cadmium Orange and flat brush no. 1, paint the desk again except for the desktop. Also paint over the Quinacridone Gold section of the book and do a quick side-to-side stroke in the middle of the desk drawer.

3. Swirl ¼ pea Naples Yellow onto the desktop to create texture. You do not want the two colors to completely mix together because that will flatten the paint.

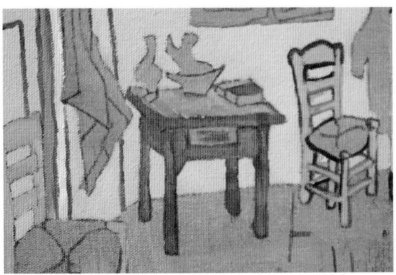

4.

4. Using ¼ pea Phthalo Blue and detail round brush no. 1, outline the desk. Look at the reference photo for guidance.

5. To paint the coatrack behind the bed, using flat brush no. 1, first paint a layer of Quinacridone Gold (¼ pea), then paint a layer of Yellow Ochre (¼ pca).

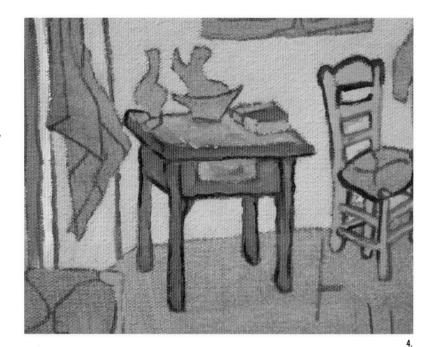

4.

5.

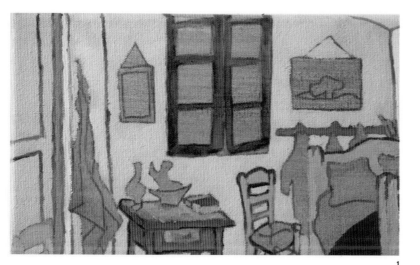

1.

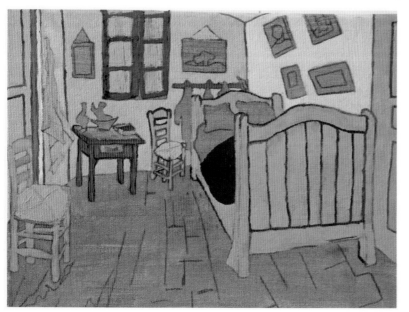

2. through 4.

PAINTING THE WINDOW, CHAIRS, AND TOWEL

1. With ½ pea Phthalo Green and flat brush no. 1, paint a thin layer on the window frame. Swirl ½ pea Cadmium Green onto the window frame to create texture. You do not want the two colors to completely mix together because that will flatten the paint.

2. With 2 peas Naples Yellow and flat brush no. 1, paint the right insides of both windowpanes, using a thicker stroke in the top panes and switching to a thinner stroke in the bottom panes.

3. Mix 1 quarter Naples Yellow with 1 dot Phthalo Green, and use flat brush no. 1 to fill in the left sides of the windowpanes.

4. Using the same green mixture as the previous step and flat brush no.1, paint the chair cushions and the towel. Leave the drawing guidelines on the cushions and towel visible, as they will be needed for reference later.

5. Use detail round brush no. 1 and leftover blue wall mixture (see step 1, "Painting the Walls and Doors," page 122) to fill in any unpainted spaces around the bottom of the window.

6. Use ½ pea Phthalo Blue and detail round brush no. 1 to outline all parts of the window frame—outer and inner. Next, outline the far-left chair with another ½ pea Phthalo Blue. Look at the reference photo for guidance.

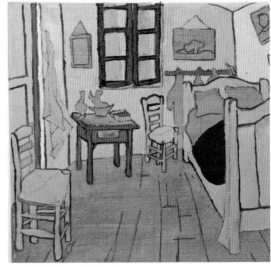

5. and 6.

7. With ¼ pea Naples Yellow and round brush no. 1, paint the bottom two slats of the far-left chair. Mix ½ pea Cadmium Red with ½ pea Terra Rosa, then use detail round brush no. 1 to outline the chair frame and cushion seaming. Use the same paint mixture to add the red detail lines to the towel—paint 3 lines at the bottom and 1 line at the top (see step 8 photo). Look at the reference photo for guidance.

8. Mix 1 dot Ivory Black with 1 pea Titanium White, then use detail round brush no.1 to line the inner folds of the towel and also completely outline the towel. It's okay if the lines aren't solid and super neat; it can be painterly. Look at Van Gogh's lines for inspiration.

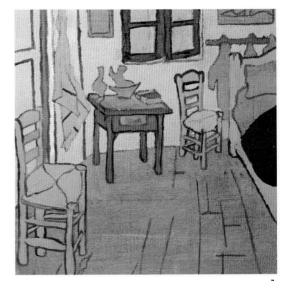
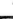

7.

8.

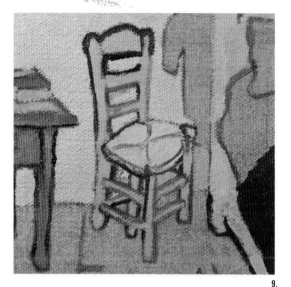

9.

9. Using the same paint mixture as in the previous step, add seam details to the cushion of the chair next to the bed.

10. To add shading to the towel, use 1 dot Phthalo Green and flat brush no. 1, and paint the bottom and right areas. Look at the reference photo for guidance.

11. Using the leftover green from steps 3 and 4 in this section (page 129) and flat brush no. 1, lightly paint the inner-front corners of the desktop and the desk drawer.

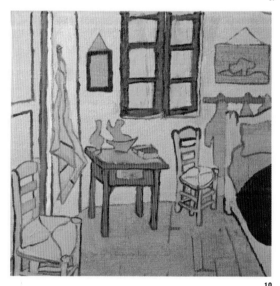

10.

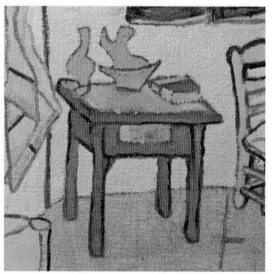

11.

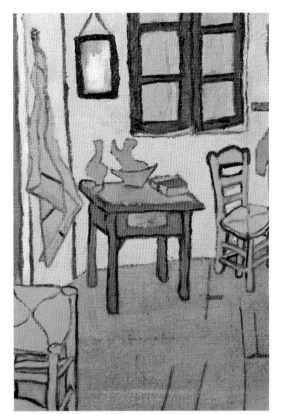

PAINTING THE MIRROR

1. Use ¼ pea Phthalo Blue and flat brush no. 1 to paint the mirror's frame. Paint ½ pea Titanium White into the center of the mirror, then grab a little of the Phthalo Blue from the frame—first pull down from the top of the frame and then pull up from the bottom. Finally, follow with a layer of ¼ pea Phthalo Green on the frame, also pulling some green into the white to add to the mirror effect.

2. Use some leftover blue wall mixture (see step 1, "Painting the Walls and Doors," page 122) and fill in the triangle above the mirror with flat brush no. 1. Use leftover Phthalo Blue with the detail round brush no. 1 to outline the hanging wire.

PAINTING THE BED LINENS, JAPANESE PRINTS, CLOTHING, AND DESK OBJECTS

1. Mix together 1 quarter each of Lemon Yellow and Titanium White. Paint the sheet and pillowcases with flat brush no. 1, then paint the backgrounds of the bottom two artworks on the right wall, above the bed.

2. With detail round brush no. 1, outline the top and sides of the left pillow with leftover Terra Rosa and use leftover Phthalo Blue to outline its left corner.

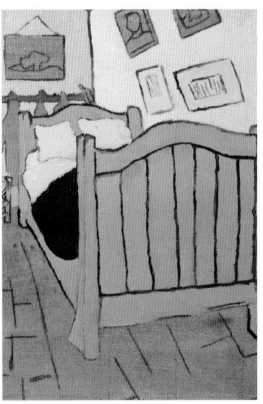

3. Use ¼ pea Phthalo Blue and detail round brush no. 1 to add the details to the bottom two artworks. On the larger work on the right, paint a horizontal rectangle with 7 vertical lines enclosed. On the smaller work, paint a vertical rectangle with 3 vertical lines enclosed. Use remaining Phthalo Blue to outline the right and bottom edges of both artworks; use leftover Terra Rosa to outline the top and left edges.

4. Use some leftover blue wall mixture (see step 1, "Painting the Walls and Doors," page 122) to fill in the two shirts on the left, hanging behind the bed.

5. Mix together ½ pea each of Cobalt Turquoise and Cerulean Blue. Use flat brush no. 1 and swirl paint around on all three shirts to achieve a drapey effect. Swirl ¼ pea Phthalo Blue into the third shirt (on the far right) to get a darker blue.

6. Paint the hat with leftover yellow bed mixture (see step 1, "Painting the Bed and Chairs," page 125). Use Phthalo Blue to outline the hat, as well as the book on the desk.

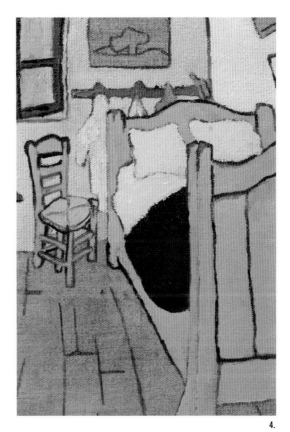

4.

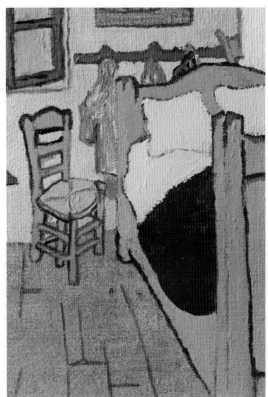

5. and 6.

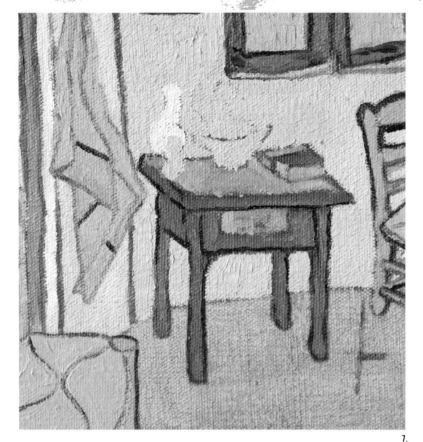

7.

7. Paint the water pitcher on the center of the desk with leftover blue wall mixture (see step 1, "Painting the Walls and Doors," page 122), keeping the drawn bowl line visible, and paint the object on the left (the decanter) Titanium White. Using blue wall mixture again, make a stroke on the front of the white decanter to indicate a glass of water.

8. Use detail round brush no. 1 to swirl leftover Phthalo Blue onto the bowl of the pitcher (center). Also use leftover Phthalo Blue to outline the decanter (left) and to shade the pitcher. Finally, use 1 pea Phthalo Blue and detail round brush no. 1 to make outlines of three bottles of varying heights on the right, behind the book. Look at the reference photo for guidance.

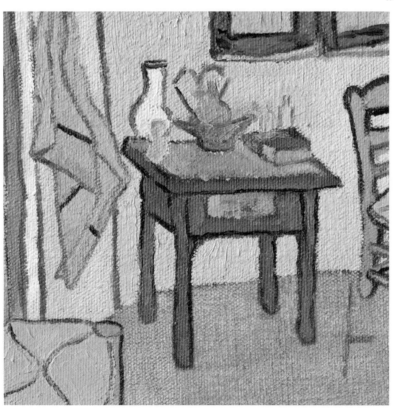

8.

1.

PAINTING THE LANDSCAPE PAINTING AND PORTRAITS

1. Starting with the landscape painting above the bed's headboard, use yellow bed mixture (see step 1, "Painting the Bed and Chairs," page 125) and detail round brush no. 1 to paint the frame. Use leftover blue wall mixture (see step 1, "Painting the Walls and Doors," page 122) to paint the sky, then swirl in Titanium White for the clouds.

2. Use detail round brush no. 1 and leftover Cadmium Green to paint the rolling hills and tree. Mix together equal amounts of leftover Phthalo Blue and Phthalo Green or ¼ pea of each, then paint the hanging wire and the outline (shadow) on the right and bottom edges of the frame.

2.

Fantastic Fact

The bottom two artworks on the right wall are Japanese prints; the landscape on the wall behind the bed is Rocks with Oak Tree; the top-left portrait is of the artist Eugène Boch; and the top-right portrait is of the soldier Paul-Eugène Milliet.

3. through 5.

3. To paint the top-left portrait on the right wall, use detail round brush no. 1 and start with the head and neck. Use ¼ pea Jaune Brillant for skin tone. Use leftover Cadmium Yellow to paint his shirt and use Burnt Umber to add facial features and hair. Fill in the portrait's background with any leftover blue.

4. To paint the top-right portrait, start with the face, using deatil round brush no. 1 and leftover Naples Yellow for skin tone. Use any leftover blue for his shirt; leftover Cadmium Red for his hat; and leftover green mixture from the window frame for the beard and background.

5. To paint the frames of both portraits, use flat brush no. 1 to paint a layer of leftover Quinacridone Gold followed by a layer of leftover Cadmium Orange, and finish with a thin layer of leftover yellow bed mixture (see step 1, "Painting the Bed and Chairs," page 125). Outline the edges of the frames with the mixture of Phthalo Blue and Phthalo Green used in step 2 in this section (page 135). Also use this mixture to outline the hanging wire of the left portrait.

Forgery Tip

If you don't feel up to painting the portraits, you can always improvise with a landscape or even an abstract work. It also helps to squint your eyes and focus on the colors and shapes rather than looking at the artwork as a whole.

1.

2. and 3.

PAINTING THE FINISHING TOUCHES

1. Continue using leftover Phthalo Blue/
 Phthalo Green mixture (see step 5,
 "Painting the Landscape Painting
 and Portraits," page 136) to outline
 the bottom of the footboard of the
 bed. If you don't have enough of this
 paint mixture left over, mix together
 1 pea of each color.

2. To paint the floor, mix 2 quarters
 Titanium White with 2 peas Burnt
 Sienna. Using flat brush no. 1, paint
 the entire floor, leaving the drawn
 guidelines for the wood cracks visible
 and the area under the far-left
 chair unpainted

3. Mix 1 quarter Naples Yellow with ½
 pea Phthalo Green (remember to use
 up any leftover paint first!). Fill in
 the unpainted space beneath the
 far-left chair.

4. To add wood texture and highlights to
 the floor, use ½ pea Titanium White
 and flat brush no. 1. Paint with a
 light touch and don't allow the colors
 to mix completely and become flat—
 it's nice to have the textural quality
 of wood. Look at the reference
 photo for guidance.

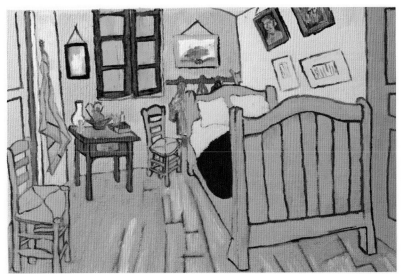

4.

5. Repeat the previous step with ½ pea Burnt Sienna.

6. To outline the lines in the wood, add 1 dot Phthalo Green to remaining floor mixture (step 2 in this section). If you want to paint quickly, use flat brush no. 1 for fatter lines, or you can use detail round brush no. 1 for thinner lines that will take a little longer to paint.

7. To finish, outline the bases of the center wall, left wall, and left-hand door with ¼ pea Cerulean Blue. Use leftover Burnt Sienna to outline the base of the right-hand door. (See image opposite for these details.) Use any remaining paint on your palette to add more of Van Gogh's signature texture. You can also continue your painting around the edges of the canvas or paint them a solid color, especially if you're not planning on framing the painting. The painting will take three days to fully dry. Store it flat on a table until it is dry.

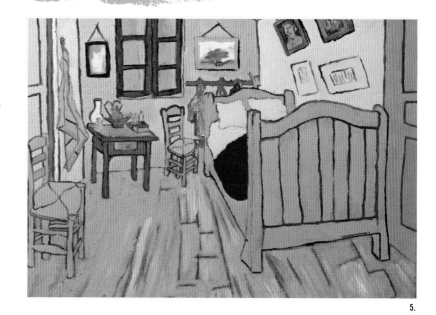

5.

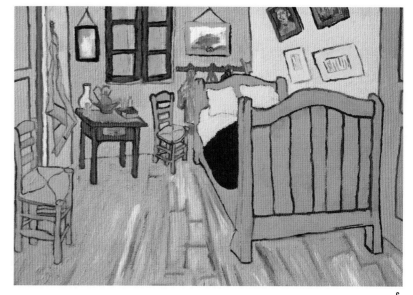

6.

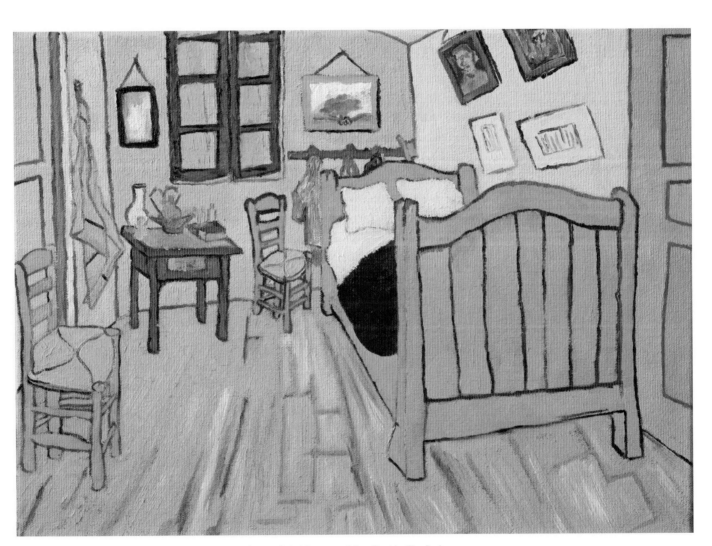
A completed forgery of Van Gogh's *The Bedroom*.

Fishing Boats

on the Beach at Les Saintes-Maries-de-la-Mer

ARLES, FRANCE, 1888

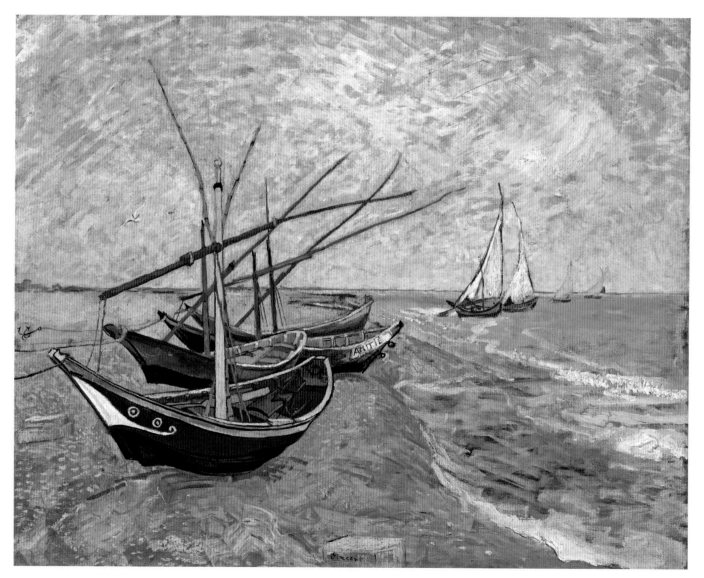

Fishing Boats on the Beach at Les Saintes-Maries-de-la-Mer, Van Gogh Museum, Amsterdam (Vincent van Gogh Foundation).

"On the completely flat, sandy beach, little green, red, blue boats so pretty in shape and color that one thought of flowers; one man boards them, these boats hardly go on the high sea—they dash off when there's no wind and come back to land if there's a bit too much."

—Vincent van Gogh in a letter to Émile Bernard, June 1888

Van Gogh's two months during the summer of 1888 in Les Saintes-Maries-de-la-Mer, a fishing village on the Mediterranean Sea, were both restful and productive. Nine drawings and three paintings (two of the sea and one of the village) were the result.

This painting of the sea, the sand, and colorful boats is an excellent example of Post-Impressionism, the artistic movement following Impressionism. Van Gogh and his contemporaries began to focus less on the effects of light and started to explore color theory.

He wrote enthusiastically about the colors of the Mediterranean Sea to Theo, saying that the sea "has a color like mackerel, in other words, changing—you don't always know if it's green or purple—you don't always know if it's blue—because a second later, its changing reflection has taken on a pink or grey hue."

Van Gogh made a drawing of the boats first and then completed the painting back in his studio. As he explained to Theo, "I made the drawing of the boats when I left very early in the morning, and I am now working on a painting based on it, a size 30 canvas with more sea and sky on the right. It was before the boats hastened out; I had watched them every morning, but as they leave very early I didn't have time to paint them."

He used bold, fluid strokes of blue and white, along with green and yellow for the waves, probably applying these colors with a palette knife. The outlines of the boats on the beach and at sea show the continuing influence of the Japanese prints Van Gogh was so fond of.

Fishing Boats

MATERIALS

- 16 × 12-inch (40 × 30 cm) canvas (you can work on a flat surface or an easel)
- Holbein Heavy Body Artist Acrylic in Raw Sienna
- Palette knife
- Sponge or paper towel
- Ruler or T-square
- No. 2 graphite pencil
- Prismacolor marker in Light Pink
- Pink Pearl Eraser
- Palette or plastic plate
- Flat brushes (nos. 1, 2, 4)
- Round brushes (nos. 1, 2)
- Detail round brush (no. 1)

OIL COLORS

Titanium White
Cerulean Blue
Phthalo Blue
Ice Green
Cobalt Turquoise
Phthalo Green Yellow Shade
Cadmium Orange
Phthalo Green
Cadmium Yellow
Yellow Ochre
Burnt Umber
Cadmium Green
Indigo
Ivory Black
Cadmium Red
Emerald Green Nova
Burnt Sienna
Naples Yellow
Cobalt Blue
Horizon Blue

PRIMING AND PREPARING THE CANVAS

1. to 3. Please refer to page 14.

4. Once your grid is prepared, it is essential to sketch an accurate drawing to use as your guide once you start painting. Use the Fishing Boats template on page 171 as your guide. You can either free-form sketch or trace the template. See "Drawing on Your Canvas" on page 9 for more instruction on how to use the template and your grid to make the drawing.

5. After completing the drawing, trace over the lines of the drawing (not the grid lines) with a Prismacolor marker. Now use your eraser to remove all the graphite pencil markings—both the drawing and the grid lines. Graphite will discolor the paint, so it is important to remove it. Don't worry about the marker—the thick lines of your Van Gogh painting will ensure that the marker is covered up.

NOTE: Though these images show a white canvas, your canvas will have been primed with the Raw Sienna acrylic paint.

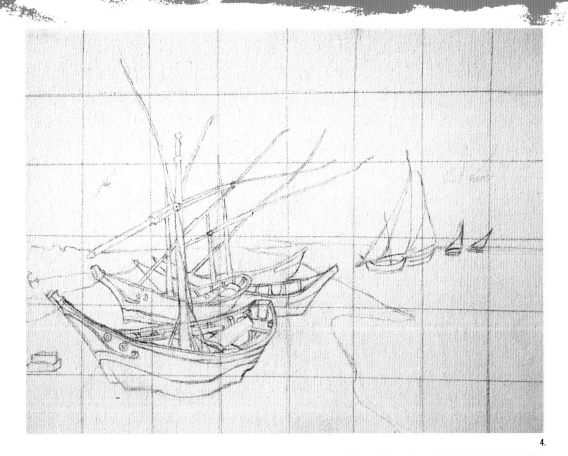

4.

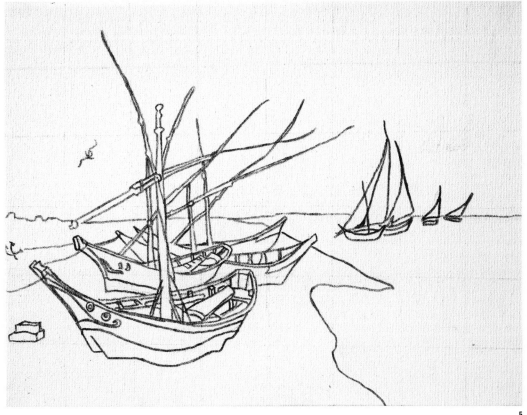

5.

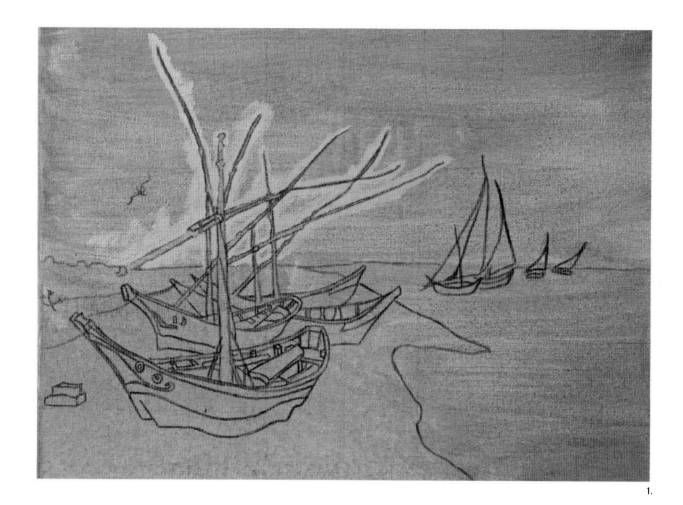

1.

PAINTING THE SKY

Note: For this section, look closely at the reference photos for guidance to get the color and movement of the sky just right.

1. In order to save yourself some time and frustration, you're going to first fill in the areas around the masts. This way you won't contaminate the boat masts with the blue of the sky and vice versa. On your palette using your palette knife, mix together 1 quarter Titanium White, 1 quarter Cerulean Blue, and 1 dot Phthalo Blue. To mix the paint using your palette knife, scoop, press, spread, and fold the paint together, until it is thoroughly and evenly mixed. Using flat brush no. 1, surround the masts and horizon line.

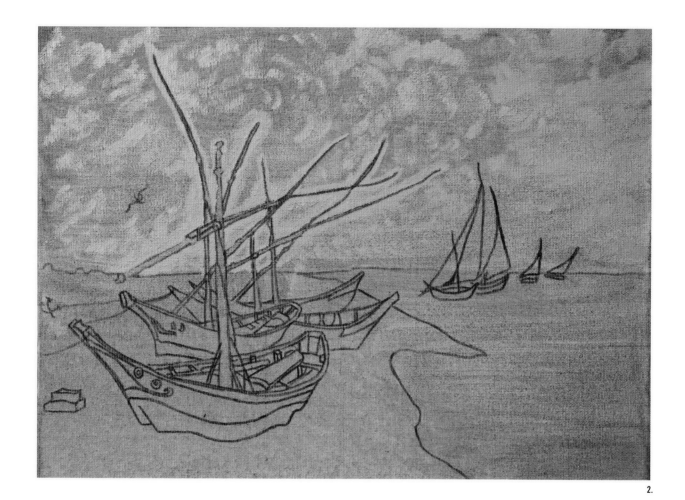

2.

2. Using the same color mixture, add dashes throughout the sky using round brush no. 1. Paint these dashes in a half-circle pattern around the masts. Gently press down and pull into a dash. You don't want your dashes to be completely uniform in size—the disparity adds the impressionistic effect you desire.

3. Mix ½ quarter Ice Green, ½ quarter Cobalt Turquoise, 1 quarter Titanium White, and 1 dot Phthalo Green Yellow Shade. (Note: Save ¼ pea of this turquoise mixture for a boat detail later in the painting. Put it to the side of your palette.) Using flat brush no. 1, paint around the far-right cluster of sailboats out at sea. In an up-and-down stroke, paint in a thick line that accentuates the horizon line between the cluster of sailboats out at sea and the sailboats on the beach. Switch to round brush no. 1 and use the same color to add more dashes at random in the half-circle pattern of movement you created in the previous step.

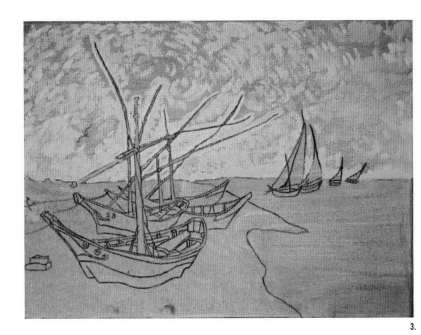

3.

Forgery Tip

This cylindrical paint application is one of Van Gogh's most beloved signature techniques for adding movement to his paintings. The subtle hint of movement in this early painting will be greatly mastered and stylized in his later works.

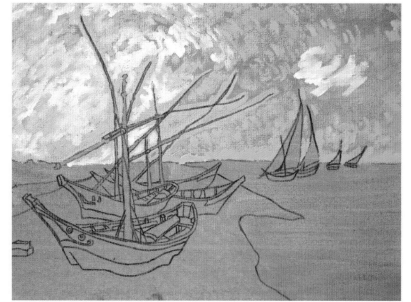

4. and 5.

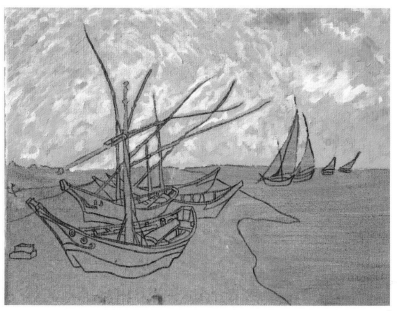

6.

4. Mix together 1 quarter each Cobalt Turquoise and Titanium White and repeat step 2, adding more dashes to your half-circle sky pattern with round brush no. 1.

5. Using 1 quarter Titanium White and round brush no. 1, add even more dashes to your half-circle sky pattern. Fill in any remaining blank spaces on the left side of your painting. Also paint the cloud-like formation on the right-hand side with dashes.

6. Use leftover blue mixtures and Titanium White to continue filling in the sky and to build up Van Gogh's signature thick texture. Follow the movement that you created with the cylindrical pattern. Notice that Van Gogh was looser with the right side of his canvas and did not keep his cylindrical pattern as tight.

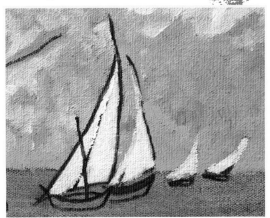

1. and 2.

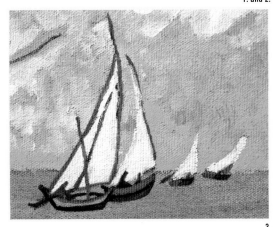

3.

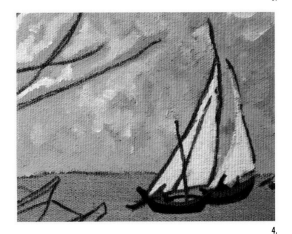

4.

PAINTING THE SAILBOATS AT SEA

1. Use 1 pea Titanium White and flat brush no. 1 to fill in the sails of the four boats.

2. Use 1 pea Cadmium Orange and detail round brush no. 1 to add details to these sailboats. Completely outline the sail of the far-left boat and paint the mast. On the sailboat second from the left, outline only the right side of the sail. Add a small triangle to the bottom-right sail of the far-right sailboat. Next, add the orange details to the hulls of the sailboats. Look at the reference photo for guidance.

3. Use ½ pea Phthalo Blue and detail round brush no. 1 to add blue details to the boats at sea. Paint a vertical line in the center of the sail of the far-left boat. Let the blue mix with the white of the sail; it will create a lighter, more vibrant blue. Look closely at the reference photo to guide you through painting the remaining blue details. Add the fishermen next by painting triangle-shaped dashes. Next, paint the rudders and the hulls of the boats, but be sure to leave space for the green detail of the hull of the far-left boat. Dip detail round brush no. 1 into leftover Titanium White and swoop a dot of white into the hulls of the boats. This will add a painterly effect and lighten the boats at random points.

4. Using detail round brush no. 1, add 1 brush dip of Phthalo Green to the unpainted strip on the hull of the far-left sailboat. Wipe off the brush and lightly dip detail round brush no. 1 in leftover Titanium White and swipe a dot through the green, mixing it directly on the canvas.

PAINTING THE
FISHING BOATS ON THE BEACH

1. Use ½ pea Cadmium Yellow and flat brush no. 1 to paint the mast of the front boat. Sweep in ¼ pea Titanium White to the yellow mast to add painterly highlights and to lighten the yellow of the mast. Allow the paint to mix directly on the canvas. With 1 pea Yellow Ochre and detail round brush no. 1, paint the tops and bottoms of the two rods that surround the mast you painted yellow.

2. Use ½ pea Burnt Umber and detail round brush no. 1 to add horizontal line details to the Yellow Ochre of the upper rods painted in the previous step. Look at the reference photo for guidance.

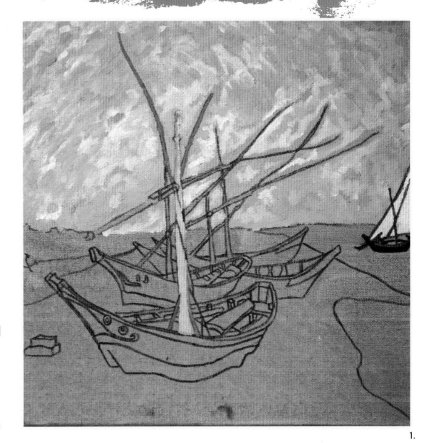

1.

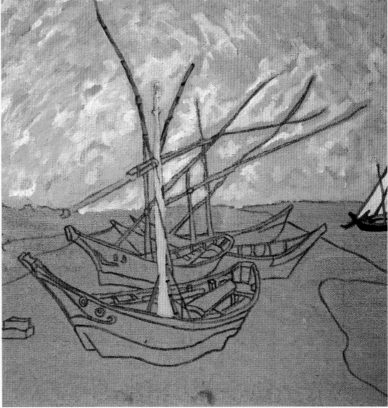

2.

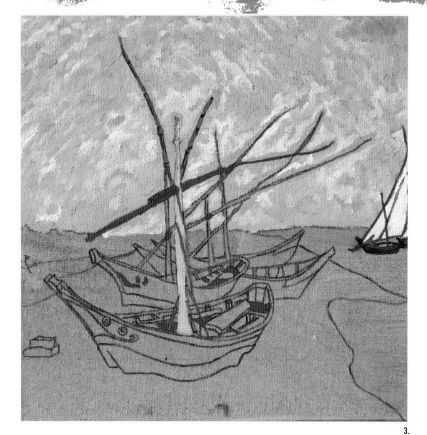

3.

3. Now you're going to add the orange details to the boats. With 2 peas Cadmium Orange and flat brush no. 1, paint the wider parts of the boom (the horizontal bar) on the front boat, switching to detail round brush no. 1 for the narrower ends. Leave the drawing guidelines visible for adding details later. Also use detail round brush no. 1 to fill in the spreaders, the two orange circle details on the masts of the second and third sailboats. Switch back to flat brush no. 1 to paint the orange interior details of the hulls of the front two boats. Start with the benches and move on to the tops of the ribs (use your photo as a reference). Again, leave the drawing guidelines visible for adding details later. Switch to detail round brush no. 1 to paint the orange decorative design on the outside of the hull of the second boat. Continue using this brush to paint the ropes coming down along the mast of the front. Wipe off the brush, and then go back over the ropes with leftover Yellow Ochre to get the desired color. Allow the paint to mix on the canvas.

4. For the green details on the second boat, use 2 peas Cadmium Green. With flat brush no. 1, paint the outer hull, the mast, and the wider parts of the boom. Switch to detail round brush no. 1 to paint the narrower parts of the boom.

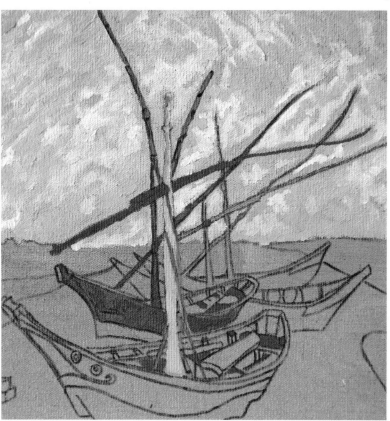

4.

5. Use 1 pea Phthalo Blue to paint the base layer of the masts and the booms of the third and fourth boats. Again, use flat brush no. 1 for the wider parts and detail round brush no. 1 for the narrower areas.

6. With ½ pea Titanium White and detail round brush no. 1, layer the white paint directly on top of the Phthalo Blue layer from the previous step, creating a painterly effect. Repeat this step with ¼ pea Cerulean Blue.

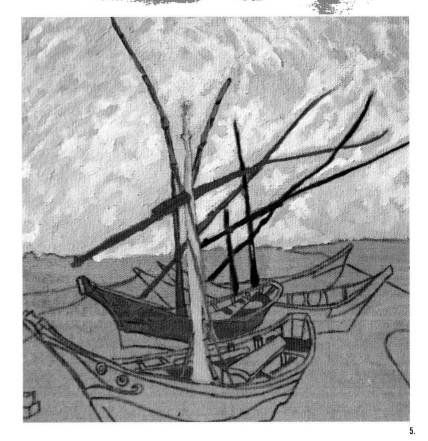

5.

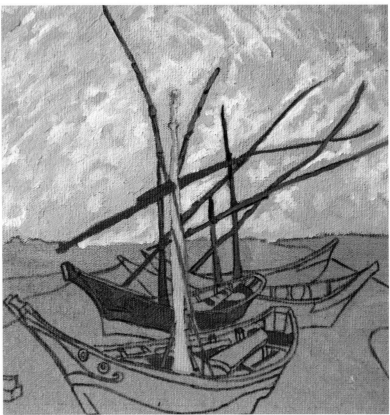

6.

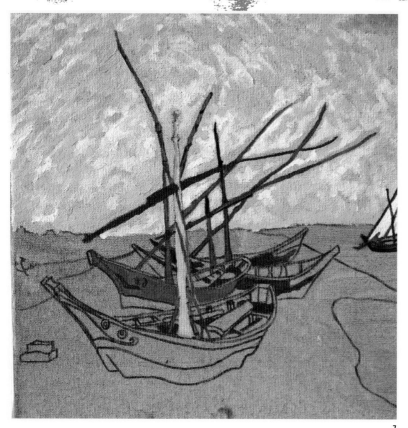

7.

7. To paint the hulls of the third and fourth boats, follow the same layering effect—½ pea each of Phthalo Blue, Titanium White, and Cerulean Blue—as in steps 5 and 6, using flat brush no. 1. Look at the reference photo for guidance as to where to paint on the hulls.

8. Use ½ quarter Indigo and flat brush no. 1 to paint the bottom portions of the hulls of all four boats.

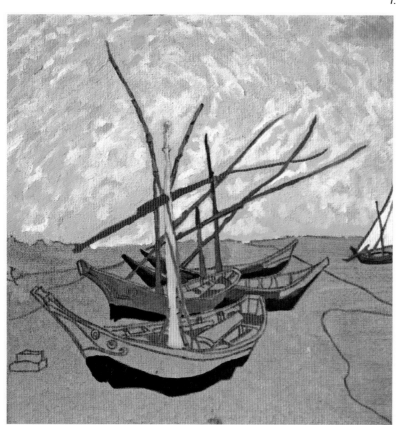

8.

9. Use ½ pea Titanium White and flat brush no. 1 to fill in the unpainted stern of the third boat, leaving the tip of the stern unpainted. Add 1 dot Black to the remaining Titanium White on your palette to create gray and fill in the tip of the stern with flat brush no. 1. Also use this gray to fill in the area of the unpainted stern, above the blue, of the fourth boat. Use ¼ pea turquoise mixture (see step 3, "Painting the Sky," page 146) that you set aside earlier with flat brush no. 1 to fill in all of the unpainted area of this same stern.

10. Mix 1 dot Indigo with 1 pea Cadmium Red, then apply this red mixture to the exterior hull of the front boat using flat brush no. 1. Leave the decorative detail on the hull unpainted.

11. Mix ½ pea Cadmium Red with 1 pea Cadmium Orange. Switch between flat brush no. 1 and detail round brush no. 1 to paint the red areas of the interior hull of the front boat. Leave the drawing guidelines visible for adding details later. Use detail round brush no. 1 and the red mixture from step 10 (that was used for the boat's outer hull) to add details to the benches of the front boat and to paint the trim on the hull of the second boat. Look at the reference photo for guidance.

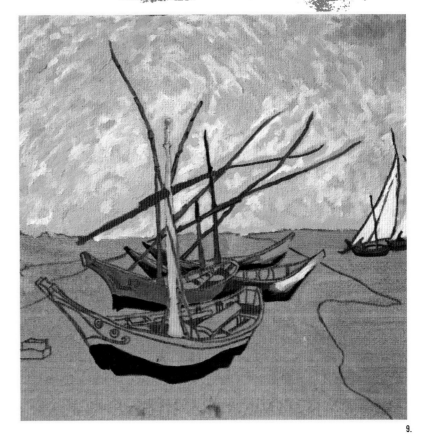

9.

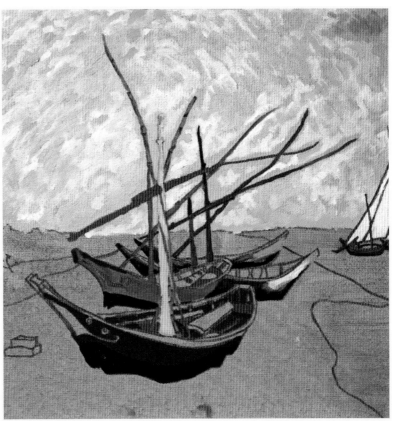

10. and 11.

12.

13.

14.

12. Use 1 pea Titanium White and flat brush no. 1 to paint part of the trim on the hull of the front boat. Using the same Titanium White, sweep a touch of it into the Indigo of the outer bottom hull of this boat with detail round brush no. 1. Mix the white directly into the blue on your canvas to highlight and shape the area. Without cleaning your brush, add a touch of blue to the white trim you just painted to create a painterly effect. Look at your reference photo for guidance. Use leftover Indigo and Titanium White to add blue board details to the objects inside of the front boat. Use the techniques of application you have learned so far to get the painterly effect.

13. Use 2 peas Titanium White and detail round brush no. 1 to paint the unpainted trim of the front boat, the trim of the hulls of the other three boats, and the interior ribs of the second and third boats. Also paint the decoration on the outer hull of the front boat. Use ¼ pea Phthalo Green Yellow Shade and detail round brush no. 1 to paint the lighter green bench detail of the interior of the second boat, then use ½ pea Emerald Green Nova and flat brush no. 1 to fill in the remaining unpainted areas of this boat's interior. Dip the detail round brush no. 1 into leftover Emerald Green Nova and gently sweep the paint onto the white hull trim and the outer hull decoration of the front boat to add a painterly effect. With ¼ pea Burnt Sienna and detail round brush no. 1, add brown wooden details to the trim and hull of the second boat. Use 1 pea Yellow Ochre and flat brush no. 1 to fill in between the ribs of the interior of the third boat. Look at the reference photo for guidance.

14. Use 1½ peas Indigo and detail round brush no. 1 to add Van Gogh's signature thin lines to the boats and to add the text "AMITIE" to the third boat. Use your reference photo for guidance.

PAINTING THE BEACH

Note: For this section, look closely at the reference photos for guidance in order to get the color and depth of the beach just right.

1. Mix 1 quarter Burnt Umber with 2 quarters Titanium White. Use flat brush no. 4 to layer in the base layer of sand all the way up to the horizon line. Allow for parts of the canvas to peek through for later paint application. Add 2 peas Naples Yellow to the sand, starting from the middle of the second boat's bow up to the horizon line using flat brush no. 2. Allow some of the original sand color to peek through and allow some of the paint to mix together as you apply.

2. Pull half of the leftover light sand mixture in step 1 to the side and mix in 1 pea Burnt Umber. Use flat brush no. 2 to paint darker sand into the beach. Allow this color to mix with the original paint layer of the beach.

3. Mix together ½ pea each of Cadmium Red and Burnt Sienna. Use round brush no. 1 to define the sand/beach underneath the first and third boats by painting in your mixture directly under the boats. Next, paint lines branching off this color to emphasize the weight of the boats as they rest on the beach. Allow this color to interact with the light sand layers but apply with a gentle hand. Use the same technique to add definition and depth to your shoreline.

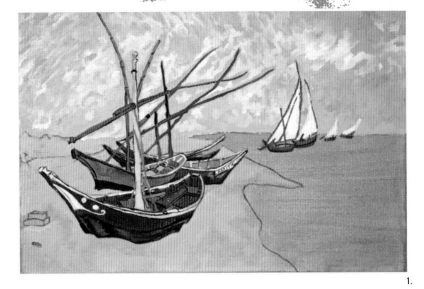

1.

2.

3.

4.

4. With 1 pea Burnt Umber and detail round brush no. 1, outline the top-right shoreline up to the stern of the third boat from the front. Save the remaining paint for later use. Go back in with leftover original light sand mixture from step 1 in this section (page 155) to add a layer of light beneath your reddish beach beneath the boats. Use detail round brush no. 1 to drop in these hints of light.

5. Mix 2 peas Titanium White with ½ pea Cobalt Blue. Use flat brush no. 1 to dust in the blue water foam onto the forefront of the beach. Use a gentle touch when applying. Next, with round brush no. 1 start stippling in 1 pea Naples Yellow onto the left side of the beach behind the brick-shaped blocks using an up-and-down dotting motion.

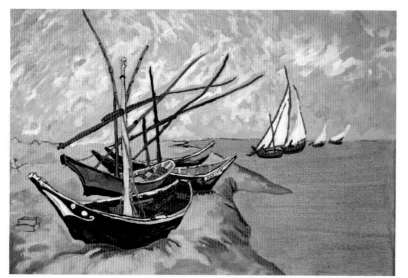

5.

6. Continue stippling in the Naples Yellow in the sand around the bows and sterns of the two front boats. Fill in the brick-shaped blocks to the left of the front boat with Naples Yellow and flat brush no. 1. Outline the blocks with the Burnt Umber you set aside in step 4 in this section and detail round brush no. 1. Use any remaining Burnt Umber and detail round brush no. 1 to add more definition and depth to the beach.

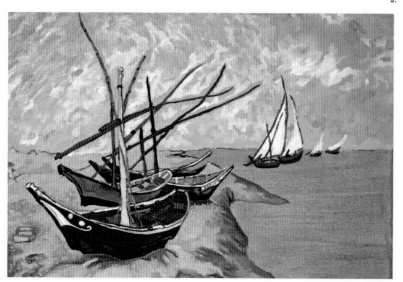

6.

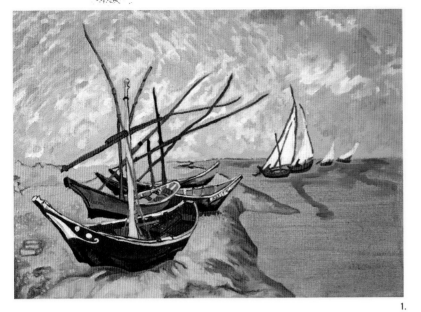

1.

PAINTING THE SEA

1. Mix 2 peas Titanium White, ¼ pea
 Cobalt Blue, and 1 dot Phthalo Blue.
 Using flat brush no. 1, drag the
 paint onto the canvas using side-
 to-side strokes, moving down from
 the horizon and painting around the
 sailboats at sea. Leave areas of the
 canvas blank for other colors.

2. Mix ½ quarter Titanium White
 with ½ pea Horizon Blue. Using
 round brush no. 2, add light
 blue water details.

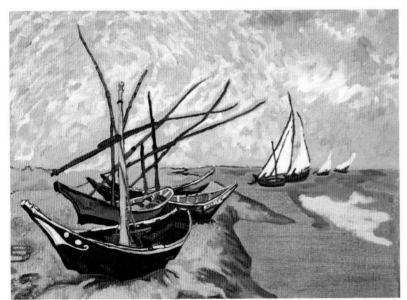

2.

Forgery Tip

*Painting the sea can be over-
whelming. It's best to squint
your eyes to see where the
colors are instead of trying to
look at the ocean as a whole.
To effectively paint water
with oils, it must be applied
in layers. Look closely at the
reference photos so you can
gradually and correctly layer
your water.*

3. Add 1 quarter Titanium White to your palette, then use round brush no. 2 to squiggle in the white water that represents the crashing waves.

4. Use round brush no. 2 to add touches of leftover Titanium White and light blue water mixture from step 2 in this section to the upper portion of the sea. Next, squiggle the light blue paint onto the lower half of the sea to resemble tiny waves creeping toward the shoreline. Also squiggle in a little of the dark-blue mixture from step 1 in this section (page 157).

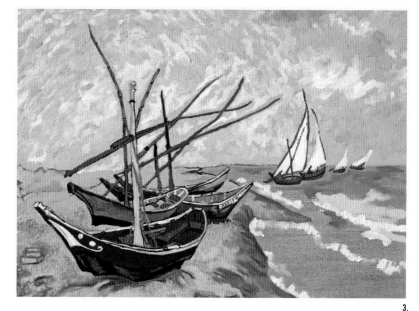

3.

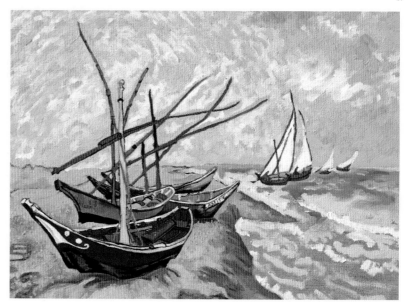

4.

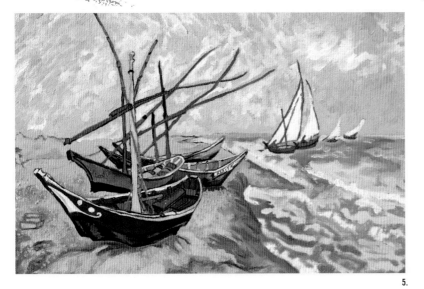

5.

5. Using round brush no. 2, add in leftover light and dark sand mixtures (see steps 1 and 2, "Painting the Beach," page 155) to the raw canvas. This layer will be covered with layers of water in the next few steps but it needs to peek through to define the sand underneath the water. Don't worry about the marker—the thick lines of your Van Gogh painting will ensure that the marker is covered up.

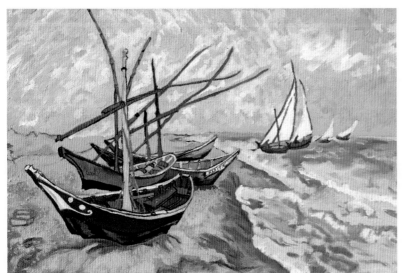

6.

6. Using round brush no. 2, add another layer of light and dark blue water mixture (see steps 1 and 2 in this section, page 157). Use a thick amount of paint so it doesn't mix too heavily with the wet sand. A little mixing is okay, but you don't want to completely muddy the blues.

7. Using round brush no. 2, apply ¼ pea Ice Green to add more definition and color to your ocean. With the same brush (wiped clean, of course), add more Titanium White to your crashing waves. Use an up-and-down stroke in places to achieve high texture.

8. Using detail round brush no. 1, add a touch of Burnt Umber to define the sand below the water.

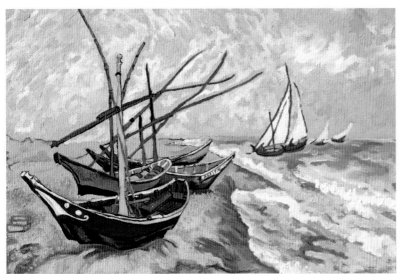

7. and 8.

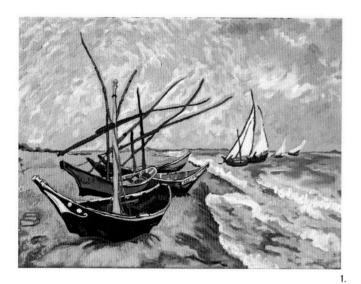

1.

PAINTING THE HORIZON

1. Use detail round brush no. 1 and Burnt Umber and Cadmium Green to define the distant vegetation on the left side of the horizon, applying an outline of Burnt Umber on the bottom and Cadmium Green on the top. Starting from the vegetation, paint in the blue horizon line with detail round brush no. 1 and leftover Cerulean Blue.

2. Add more shore definition to the upper right-hand shore using detail round brush no. 1 and Burnt Umber.

PAINTING THE FINISHING TOUCHES

1. Use detail round brush no. 1 and leftover paint to finish these details (see image opposite for these details):
 - Add straps to the orange boom of the front boat using light blue water mixture (see step 2, "Painting the Sea," page 157).
 - Use Cadmium Orange to paint in ropes, hanging in an upside-down V-shape, from the booms to the hulls of the third and fourth boats.
 - Use Indigo to paint the rope and anchor coming off the bow of the third boat.
 - Also use Indigo to paint the rope coming off the bow of the first boat.
 - Add a second rope coming off the bow of the third boat using dark sand mixture.
 - Add two ropes coming from the bow of the second boat: paint one with Burnt Umber and the other with the dark sand mixture (see step 2, "Painting the Beach," page 155).
 - Paint two seagulls to the left of the masts using a combination of Cerulean Blue, Phthalo Blue, and Titanium White. Look closely at the reference photo to get your lines just right.

2. Use any remaining paint on your palette to add more of Van Gogh's signature texture. You can also continue your painting around the edges of the canvas or paint them a solid color, especially if you're not planning on framing the painting. The painting will take three days to fully dry. Store it flat on a table until it is dry.

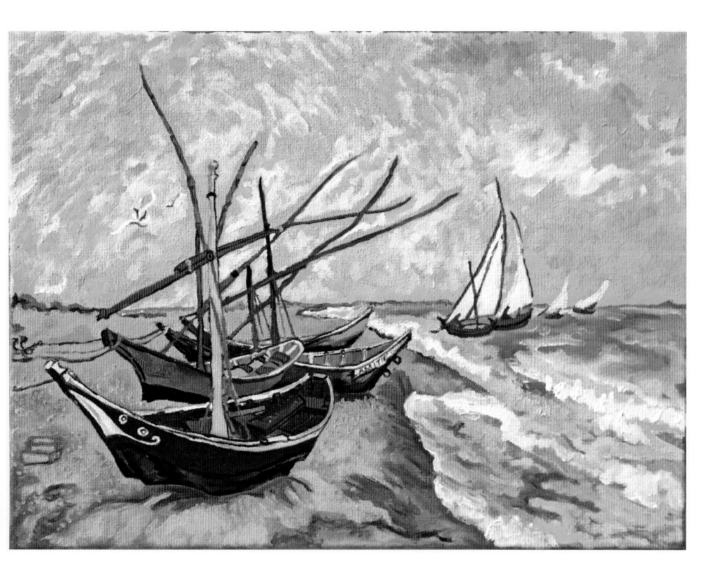

A completed forgery of Van Gogh's *Fishing Boats on the Beach at Les Saintes-Maries-de-la-Mer.*

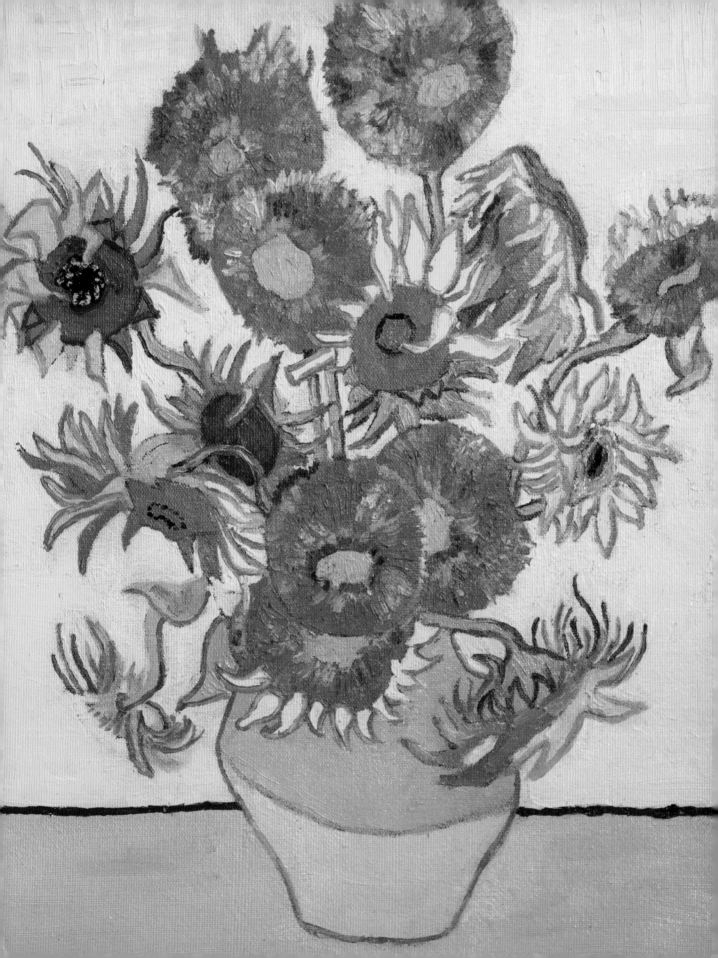

Drawing Templates

Artist Acknowledgments

I would like to thank Jeannine Dillon, Erin Canning, Jason Chappell, and the rest of the Quarto family for fostering me as a first-time illustrator. I would especially like to thank Jeannine for approaching me with such an amazing project and for her patience, guidance, and support as I brought it to life.

I would like to thank the Van Gogh Museum in Amsterdam, as well as Vincent Van Gogh for his inspiring resilience through a career full of disappointments, torments, and failures that was just long enough to gift us with his painting technique and style. I will forever be awestruck by his creations.

I would like to thank my family, especially my parents, Connie and Page Lea, for supporting and encouraging me to listen to my creative spirit and pursue the arts. Without you I could never be so brave.

After months of planning this book, I was in an accident on my way to begin painting these works, leaving me with multiple disc injuries in my spine. I would like to thank my talented physical therapist, Anthony Rojas, who was with me every step of this book and whose healing made this possible. I would like to thank my Brooklyn family, John Pappas and Erik Nuenighoff, for taking care of me physically and mentally and making sure I was up every day, with my shoes on, ready to paint. I would like to thank Raul Nunez and Rachelle Dragani for their "couch of hospitality" and keeping me fed and laughing through this difficult time. Thank you to Tito Pedraza, aka my own personal "Tony Robbins." Thank you to Bobby Thomson, Ashley Sawyer, Paul Scarborough, Andrew Dreps, Nic Dell, Sasha Grafit, Julie and Ellis Norman, Jim Wagner, Jasmine Britt, and Karl Sluis for keeping my spirits lifted. Thank you to John Lea for the late-night FaceTimes filled with both comedy and tough love to keep me pushing on through the pain.

I would like to thank the group of inspiring and empowered women I am honored to call my friends: Morika Ogawa, Regina Diperna, Lee Upshur, Liz Westendorf, and Rachel Hoffheimer. I am constantly amazed at our ability to teach and support one other as we grow within our own careers and lives. A huge thank-you to the extraordinarily talented Tawni Bannister for photographing my portrait and making me so comfortable on the other side of the camera.

I would like to thank my closest ally, Iris Scott, for giving me the courage to paint full time and for mentoring me every step of the way. Thank you for inspiring me to jump off a cliff and build the plane on the way down.

Lastly, I would like to thank my dearest friend, Loran Whigham, without whom none of this could ever be possible. Thank you for magically appearing when I need you the most, for being my loudest cheerleader, and always giving me a place to paint.

About the Artist

Susan Lea is a Brooklyn-based artist and illustrator. Born and raised in Virginia Beach, Virginia, Susan's first exposure to forgery unfolded in high school. A color-mixing assignment led her to paint a copy of Van Gogh's *Wheatfield with Cypresses* and she has been painting ever since. At Sweet Briar College, she received classical training in oil painting and a B.A. in studio art. After graduating, Susan headed west and discovered her love for teaching painting in San Diego, California, at the Young at Art Children's Creative Center. Susan returned to Virginia Beach to become the director of Abrakadoodle® of Virginia Beach, Norfolk, and the Eastern Shore. Through this art-education franchise, Susan brought lessons rooted in art history to thousands of children.

Susan relocated to Brooklyn, New York, in 2013 and began pursuing an art career of her own. Susan's oil paintings are heavily influenced by the landscapes and wildlife of coastal Virginia and North Carolina. She loves surrounding herself with the nature of her youth while living a fast-paced city life. You can view her prints and originals by visiting her website, susanleafineart.com.

SUSAN LEA FINE ART

@SUSANLEAFINEART

About the Author

Joanne Shurvell moved to London from Canada in 1996 to escape the cold winters and for a job with a British book publisher. Since then, she has been the marketing director at various publishers, including Oxford University Press and Orion; for an online shopping mall; and at the Institute of Contemporary Arts. The latter post prompted her, with business partner James Payne, to open PayneShurvell, a contemporary art gallery in Shoreditch, East London, in June 2010. Although they closed the Shoreditch gallery in 2014, they continue to organize exhibitions and represent artists in temporary locations in the UK and Europe.

When she's not running PayneShurvell, Joanne writes on the arts, culture, and travel. She currently writes for *Forbes* and has contributed to *Garageland*, Yahoo, World Travel Guide, and *Zoomer* magazine, and is also the arts and travel feature editor for *Design Exchange* magazine. Joanne is the co-author of the Citysketch series of books, which include *London*, *Paris*, and *New York*, and are also published by Race Point.

About the Van Gogh Museum

The Van Gogh Museum in Amsterdam, the Netherlands, has the world's largest and finest collection of Vincent van Gogh's paintings and drawings. The museum also provides an excellent way to understand and appreciate his artwork in context with his influences and his contemporaries.

The museum's collection also includes works by Van Gogh's personal friends, such as Paul Gaugin and Émile Bernard, to see what he would have seen, along with the work of his contemporaries, such as Claude Monet and Édouard Manet, in order to get a sense of the larger aesthetic movements of the time. There are also Japanese prints on display to see how these influenced many of Van Gogh's paintings.

The museum is located in Museumplein in the borough of Amsterdam South, close to the Stedelijk Museum, the Rijksmuseum, and the Concertgebouw. The museum was founded in 1973 and is located in a building designed by Gerrit Rietveld.